Repetitive Muster • Motivos recurrentes
Padrões Repetidos • Motifs répétés • Schemi ripetitivi
重复图案 • Узоры и орнаменты • 繰り返し模様

Repeating Patterns
1100 – 1800

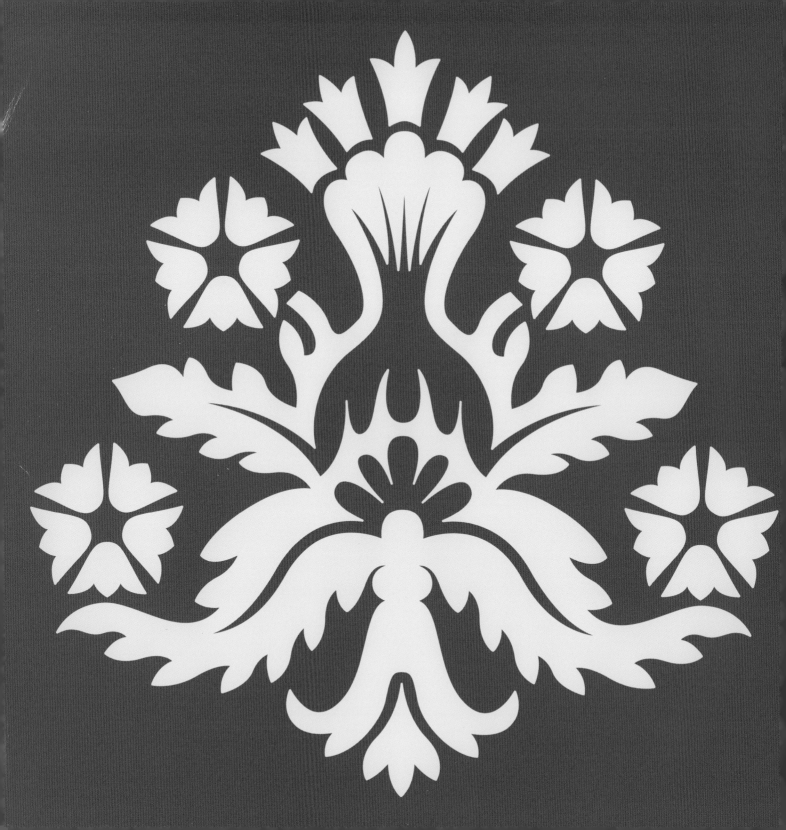

Colophon

The Pepin Press | Agile Rabbit Editions
P.O. Box 10349
1001 EH Amsterdam, The Netherlands

Tel +31 20 420 20 21
Fax +31 20 420 11 52
mail@pepinpress.com
www.pepinpress.com

Design & text by Pepin van Roojen

Picture scanning and restoration by
Jakob Hronek

Layout by Pepin van Roojen & Inge Stevens

ISBN 978 90 5768 119 6

10 9 8 7 6 5 4 3 2 1
2013 12 11 10 09 08

Manufactured in Singapore

Contents

Free CD-Rom inside the back cover

The Pepin Press | Agile Rabbit Editions

The Pepin Press publishes a wide range of books on art, design, architecture, applied art, and popular culture.

We have published numerous books highlighting design elements from historical periods and world cultures. These include:

Historical Styles
Mediæval Patterns
Gothic Patterns
Renaissance Patterns
Baroque Patterns
Rococo Patterns
Art Nouveau Designs
Jugendstil
Fancy Designs 1920
Patterns of the 1930s

Cultural Styles
Islamic Designs from Egypt
Turkish Designs
Islamic Designs
Arabian Geometric Patterns
Persian Designs
Chinese Patterns
Japanese Patterns
Japanese Papers

Tile Designs
Traditional Dutch Tile Designs
Barcelona Tile Designs
Tile Designs from Portugal
Havana Tile Designs

Packaging & Folding
How To Fold
Folding Patterns for Display and Publicity
Structural Package Designs
Special Packaging
Take One
Mail It!

Textile Patterns
Ikat Patterns
Batik Patterns
Weaving Patterns
Lace
Embroidery
Indian Textile Prints
Flower Power
European Folk Patterns
Kimono Patterns
Tapestry
Textile Motifs of India
Fabric Textures and Paterns

Pattern and Design Collections
Floral Patterns
Paisley Patterns
Marbled Paper Designs
Watercolour Patterns
Wallpaper Designs
Geometric Patterns
Biological

Web Design
Web Design Index by Content.03
Web Design Index 8

Picture collections
World Musical Instruments
(No) Dog signs
Historical and Curious Maps
Astrology Pictures
Mythology Pictures
Menu Designs

Fashion books
Fifties Fashion
Fashion Prints
Fashion Design 1800-1940
Art Deco Fashion
Spectacles & Sunglasses
Bags
Figure Drawing for Fashion Design
Fashion Accessories
Wrap and Drape Fashion

Art books
Crown Jewellery
Ethnic Jewellery
The Straits Chinese
Batik Design

Graphic Themes
Fancy Alphabets
Signs and Symbols
1000 Decorated Initials
Graphic Frames
Graphic Ornaments

Photographs
Flowers
Fruit
Vegetables

For a complete list of available titles, please visit our website at: www.pepinpress.com

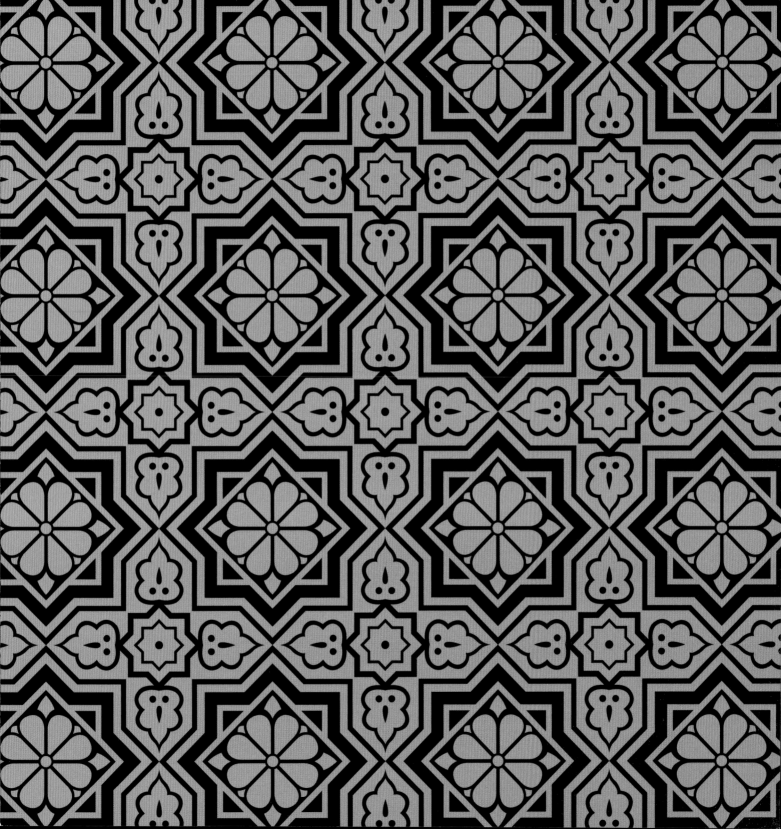

Introduction

This book and CD-Rom set contains a stunning collection of repeating patterns from the Middle Ages, the Renaissance and the Baroque period. The earlier designs often show domestic animals and animals associated with hunting, such as dogs and deer, or mythical and fantastic beasts, such as unicorns. The later designs are dominated by floral compositions. All periods covered in this book include designs with a clear geometric element.

All designs in this book have been taken from authentic period originals, for the most part from tapestries and other textiles. The often highly intricate repeating quality of the designs makes them suitable for limitless patterns and an infinite range of applications.

CD-ROM and Images Rights

The images in this book can be used as a graphic resource and for inspiration. All the illustrations are stored on the enclosed CD-ROM and are ready to use for printed media and web page design. The pictures can also be used to produce postcards, either on paper or digitally, or to decorate your letters, flyers, T-shirts, etc. They can be imported directly from the CD into most software programs. Some programs will allow you to access the images directly; in others, you will first have to create a document, and then import the images. Please consult your software manual for instructions.

The names of the files on the CD-ROM correspond with the page numbers in this book. The CD-ROM comes free with this book, but is not for sale separately. The files on Pepin Press/Agile Rabbit CD-ROMs are sufficiently large for most applications. However, larger and/or vectorised files are available for most images and can be ordered from The Pepin Press/Agile Rabbit Editions.

For non-professional applications, single images can be used free of charge. The images cannot be used for any type of commercial or otherwise professional application – including all types of printed or digital publications – without prior permission from The Pepin Press/Agile Rabbit Editions. Our permissions policy is very reasonable and fees charged, if any, tend to be minimal.

For inquiries about permissions and fees, please contact:
mail@pepinpress.com
Fax +31 20 4201152

Introduzione

Questo libro con il CD-ROM accluso contiene una splendida collezione di schemi ripetitivi del Medio Evo, del Rinascimento e del Barocco. I disegni più antichi mostrano spesso animali domestici o associati alla caccia, come i cani e i cervi, oppure delle bestie mitiche e fantastiche come gli unicorni. I disegni più recenti sono dominati dalle composizioni floreali. Tutti i periodi rappresentati nel libro includono disegni con elementi geometrici.

Tutti gli schemi di questo libro sono stati tratti da immagini originali antiche, principalmente da arazzi o da altri tessuti. La qualità spesso intricata e ripetitiva dei disegni li rende ideali per la creazione di schemi illimitati e per una serie infinita di applicazioni.

CD ROM e diritti d'immagine

Le immagini contenute in questo libro possono essere utilizzate come risorsa grafica e come ispirazione. Tutte le illustrazioni sono salvate sul CD ROM incluso e sono pronte ad essere utilizzate per la stampa su qualsiasi tipo di supporto e per il design di pagine web. Le immagini possono anche essere utilizzate per produrre delle cartoline, in forma stampata o digitale, o per decorare le vostre lettere, volantini, magliette, eccetera. Possono essere direttamente importate dal CD nella maggior parte dei programmi software. Alcuni programmi vi permetteranno l'accesso diretto alle immagini; in altri, dovrete prima creare un documento, e poi importare le immagini. Vi preghiamo di consultare il manuale del vostro software per ulteriori istruzioni.

I nomi dei file sul CD ROM corrispondono ai numeri di pagina indicati nel libro. Il CD ROM viene fornito gratis con il libro, ma non è in vendita separatamente. I file sui CD ROM della Pepin Press/Agile Rabbit sono di dimensione adatta per la maggior parte delle applicazioni. In ogni caso, per la maggior parte delle immagini sono disponibili file più grandi o vettoriali, che possono essere ordinati alla Pepin Press/ Agile Rabbit Editions.

Delle singole immagini possono essere utilizzate senza costi aggiuntivi a fini non professionali. Le immagini non possono essere utilizzate per nessun tipo di applicazione commerciale o professionale – compresi tutti i tipi di pubblicazioni stampate e digitali – senza la previa autorizzazione della Pepin Press/ Agile Rabbit Editions. La nostra gestione delle autorizzazioni è estremamente ragionevole e le tariffe addizionali applicate, qualora ricorrano, sono minime.

Per ulteriori domande riguardo le autorizzazioni e le tariffe, vi preghiamo di contattarci ai seguenti recapiti:
mail@pepinpress.com
Fax +31 20 4201152

Introduction

Ce lot livre-CD-Rom contient une superbe collection de motifs répétitifs du Moyen-âge, de la Renaissance et de l'époque baroque. Les motifs les plus anciens représentent des animaux domestiques ainsi que des animaux dans des scènes de chasse, tels que des chiens et des cerfs, ou encore des bêtes mythiques ou fantastiques, telles que des licornes. Dans les motifs plus modernes dominent les compositions florales. Toutes les périodes abordées dans ce livre contiennent des styles caractérisés par un élément clairement géométrique.

Tous les styles de ce livre sont tirés d'originaux authentiques des différentes périodes, pour la plupart des tapisseries et d'autres textiles. En raison de la qualité de répétition souvent très compliquée des styles, ceux-ci conviennent à des motifs illimités et une gamme infinie d'applications.

CD-ROM et droits d'auteur

Les images contenues dans ce livre peuvent servir de ressources graphiques ou de source d'inspiration. Toutes les illustrations sont stockées sur le CD-ROM ci-joint et sont prêtes à l'emploi sur tout support imprimé ou pour la conception de site Web. Elles peuvent également être employées pour créer des cartes postales, en format papier ou numérique, ou pour décorer vos lettres, prospectus, T-shirts, etc. Ces images peuvent être importées directement du CD dans la plupart des logiciels. Certaines applications vous permettent d'accéder directement aux images, tandis que d'autres requièrent la création préalable d'un document pour pouvoir les importer. Veuillez vous référer au manuel de votre logiciel pour savoir comment procéder.

Les noms des fichiers du CD-ROM correspondent aux numéros de page de cet ouvrage. Le CD-ROM est fourni gratuitement avec ce livre, mais ne peut être vendu séparément. Les fichiers des CD-ROM de The Pepin Press/Agile Rabbit sont d'une taille suffisamment grande pour la plupart des applications. Cependant, des fichiers plus grands et/ou vectorisés sont disponibles pour la plupart des images et peuvent être commandés auprès des éditions The Pepin Press/Agile Rabbit.

Des images seules peuvent être utilisées gratuitement à des fins non professionnelles. Les images ne peuvent pas être employées à des fins commerciales ou professionnelles (y compris pour tout type de publication sur support numérique ou imprimé) sans l'autorisation préalable expresse des éditions The Pepin Press/Agile Rabbit. Notre politique d'autorisation d'auteur est très raisonnable et le montant des droits, le cas échéant, est généralement minime.

Pour en savoir plus sur les autorisations et les droits d'auteur, veuillez contacter :
mail@pepinpress.com
Fax +31 20 4201152

Introducción

Este libro con CD contiene una fascinante colección de motivos recurrentes datados de la Edad Media, el Renacimiento y el barroco. Los motivos más tempranos con frecuencia reproducen animales domésticos o relacionados con la caza, como perros y venados, o bien seres mitológicos y fantásticos, como unicornios. En los motivos posteriores predominan las composiciones florales. Todas las épocas abordadas en este volumen cuentan con diseños con un elemento geométrico inconfundible.

Los motivos de este libro se han extraído en su totalidad de originales auténticos de la época, principalmente de tapices y otros tejidos. El aspecto intricado de muchos de estos motivos permite aplicarlos en repeticiones ilimitadas y con infinidad de usos.

CD-ROM y derechos sobre las imágenes

Este libro contiene imágenes que pueden servir como material gráfico o simplemente como inspiración. Todas las ilustraciones están incluidas en el CD-ROM adjunto y pueden utilizarse en medios impresos y diseño de páginas web. Las imágenes también pueden emplearse para crear postales, ya sea en papel o digitales, o para decorar sus cartas, folletos, camisetas, etc. Pueden importarse directamente desde el CD a diferentes tipos de programas. Algunas aplicaciones informáticas le permitirán acceder a las imágenes directamente, mientras que otras le obligarán a crear primero un documento y luego importarlas. Consulte el manual de software pertinente para obtener instrucciones al respecto.

Los nombres de los archivos contenidos en el CD-ROM se corresponden con los números de -página del libro. El CD-ROM se suministra de forma gratuita con el libro. Queda prohibida su venta por separado. Los archivos incluidos en los discos CD-ROM de Pepin Press/Agile Rabbit tienen una resolución suficiente para su uso con la mayoría de aplicaciones. Sin embargo, si lo precisa, puede encargar archivos con mayor definición y/o vectorizados de la mayoría de las imágenes a The Pepin Press/Agile Rabbit Editions.

Para aplicaciones no profesionales, pueden emplearse imágenes sueltas sin coste alguno. Estas imágenes no pueden utilizarse para fines comerciales o profesionales (incluido cualquier tipo de publicación impresa o digital) sin la autorización previa de The Pepin Press/Agile Rabbit Editions. Nuestra política de permisos es razonable y las tarifas impuestas tienden a ser mínimas.

Para solicitar información sobre autorizaciones y tarifas, póngase en contacto con:
mail@pepinpress.com
Fax +31 20 4201152

Einleitung

Dieses Buch und die beiliegende CD-ROM enthalten eine spektakuläre Sammlung repetitiver Muster aus dem Mittelalter, der Renaissance und dem Barock. Während die frühen Muster dieser Art häufig Haustiere und Jagdtiere wie Hunde und Hirsche oder mythische und fantastische Fabelwesen wie Einhörner zeigten, dominieren bei den späteren Designs vor allem florale Kompositionen. Zusätzlich gab es in allen Epochen, die in diesem Buch vorgestellt werden, eine große Zahl von geometrischen Musterelementen.

Sämtliche Designs in diesem Buch wurden nach Originalen der jeweiligen Epoche reproduziert, zumeist nach Tapisserien und anderen Textilien. Die häufig äußerst kunstvoll gearbeiteten, wiederkehrenden Muster eignen sich ideal für Endlosmuster und eine Vielzahl von Anwendungsbereichen.

CD-ROM und Bildrechte

Dieses Buch enthält Bilder, die als Ausgangsmaterial für grafische Zwecke oder als Anregung genutzt werden können. Alle Abbildungen sind auf der beiliegenden CD-ROM gespeichert und lassen sich direkt zum Drucken oder zur Gestaltung von Webseiten einsetzen. Sie können die Designs aber auch als Motive für Postkarten (auf Karton bzw. in digitaler Form) oder als Ornament für Ihre Briefe, Broschüren, T-Shirts usw. verwenden. Die Bilder lassen sich direkt von der CD in die meisten Softwareprogramme laden. Bei einigen Programmen lassen sich die Grafiken direkt einladen, bei anderen müssen Sie zuerst ein Dokument anlegen und können dann die jeweilige Abbildung importieren. Genauere Hinweise dazu finden Sie im Handbuch Ihrer Software.

Die Namen der Bilddateien auf der CD-ROM entsprechen den Seitenzahlen dieses Buchs. Die CD-ROM wird kostenlos mit dem Buch geliefert und ist nicht separat verkäuflich. Alle Bilddateien auf den CD-ROMs von The Pepin Press/Agile Rabbit wurden so groß dimensioniert, dass sie für die meisten Applikationen ausreichen; zusätzlich können jedoch größere Dateien und/oder Vektorgrafiken der meisten Bilder bei The Pepin Press/Agile Rabbit Editions bestellt werden.

Einzelbilder dürfen für nicht-professionelle Anwendungen kostenlos genutzt werden; dagegen muss für die Nutzung der Bilder in kommerziellen oder sonstigen professionellen Anwendungen (einschließlich aller Arten von gedruckten oder digitalen Medien) unbedingt die vorherige Genehmigung von The Pepin Press/ Agile Rabbit Editions eingeholt werden. Allerdings handhaben wir die Erteilung solcher Genehmigungen meistens recht großzügig und erheben – wenn überhaupt – nur geringe Gebühren.

Für Fragen zu Genehmigungen und Preisen wenden Sie sich bitte an:
mail@pepinpress.com
Fax +31 20 4201152

Introdução

Este conjunto de livro e CD-ROM contém uma fabulosa colecção de padrões repetidos da Idade Média, do Renascimento e do Barroco. Os desenhos mais antigos retratam muitas vezes animais domésticos e animais associados à caça, como cães ou veados, ou criaturas míticas e fantásticas, como os unicórnios. Nos desenhos mais recentes, predominam as composições florais. Todos os períodos abrangidos por este livro incluem desenhos com um elemento claramente geométrico.

Todos os desenhos deste livro foram retirados de originais autênticos dos respectivos períodos, na sua maioria tapeçarias e outros têxteis. A qualidade repetitiva muitas vezes altamente intricada dos desenhos torna-os adequados para padrões ilimitados e para as mais diversas aplicações.

CD-ROM e direitos de imagem

As imagens neste livro podem ser usadas como recurso gráfico e fonte de inspiração. Todas as ilustrações estão guardadas no CD-ROM incluído e prontas a serem usadas em suportes de impressão e design de páginas web. As imagens também podem ser usadas para produzir postais, tanto em papel como digitalmente, ou para decorar cartas, brochuras, T-shirts e outros artigos. Podem ser importadas directamente do CD para a maioria dos programas de software. Alguns programas permitem aceder às imagens directamente, enquanto que noutros, terá de primeiro criar um documento para poder importar as imagens. Consulte o manual do software para obter instruções.

Os nomes dos ficheiros no CD-ROM correspondem aos números de páginas no livro. O CD-ROM é oferecido gratuitamente com o livro, mas não pode ser vendido separadamente. A dimensão dos ficheiros nos CD-ROMs da Pepin Press/Agile Rabbit é suficiente para a maioria das aplicações. Contudo, os ficheiros maiores e/ou vectorizados estão disponíveis para a maioria das imagens e podem ser encomendados junto da Pepin Press/Agile Rabbit Editions.

Podem ser usadas imagens individuais gratuitamente no caso de utilizações não profissionais. As imagens não podem ser usadas para qualquer tipo de utilização comercial ou profissional, incluindo todos os tipos de publicações digitais ou impressas, sem autorização prévia da Pepin Press/Agile Rabbit Editions. A nossa política de autorizações é muito razoável e as tarifas cobradas, caso isso se aplique, tendem a ser bastante reduzidas.

Para esclarecimentos sobre autorizações e tarifas, queira contactar:
mail@pepinpress.com
Fax +31 20 4201152

Введение

В этой книге и на компакт-диске собрана удивительная коллекция узоров и орнаментов средних веков, эпохи Возрождения и периода Барокко. На ранних эскизах часто изображались домашние животные и животные из сцен охоты (собаки, олени), а также мифические существа, например, единороги. На эскизах более позднего времени доминировали цветочные композиции. Эскизы всех периодов, охватываемых в книге, содержат четко выраженные геометрические элементы.

Все эскизы данной книги сняты с подлинников соответствующего периода, большей частью с гобеленов и других текстильных изделий. Высокое качество воспроизведения эскизов делает их весьма подходящими для создания бесконечного разнообразия узоров и орнаментов в бесчисленных применениях.

Авторские права на компакт-диск и изображения

Изображения, представленные в этой книге, можно использовать в качестве графического ресурса и как источник вдохновения. Все иллюстрации хранятся на прилагаемом компакт-диске. Их можно распечатывать и применять при разработке веб-страниц. Кроме того, иллюстрации можно использовать при изготовлении открыток, как на бумаге, так и цифровых, а также для украшения писем, рекламных материалов, футболок и т.д. Изображения можно непосредственно импортировать в большинство программ. В одних приложениях можно получить прямой доступ к иллюстрациям, в других придется сначала создать документ, а затем уже импортировать изображения. Конкретные рекомендации см. в руководстве по программному обеспечению.

Имена файлов на компакт-диске соответствуют номерам страниц этой книги. Компакт-диск прилагается к книге бесплатно, но отдельно он не продается. Файлы на компакт-дисках Pepin Press/ Agile Rabbit достаточно велики для большинства приложений. Однако для многих изображений в The Pepin Press/Agile Rabbit Editions можно заказать и файлы большего объема или файлы векторизованных изображений.

В применениях непрофессионального характера отдельные изображения можно использовать бесплатно. Изображения нельзя использовать в любых видах коммерческих или других профессиональных применений – включая все виды печатной и цифровой публикации – без предварительного разрешения The Pepin Press/Agile Rabbit Editions. Наша политика выдачи разрешений достаточно обоснованна и расценки оплаты, если таковая вообще потребуется, обычно минимальны.

С запросами по поводу разрешений и оплаты обращайтесь:
mail@pepinpress.com
Факс +31 20 4201152

简介

本书及 CD-ROM 光碟套装收集了多款源自中世纪、文艺复兴及巴洛克时期的重复图案。早期的设计 题材多是家畜及与狩猎有关的动物, 如犬和鹿, 又或是神话和传说中的兽类, 如独角兽。后期的设计则多以花卉组合为主。无论是源自哪个时期, 本书所收集的图案设计均包含了几何图形的元素。

本书收集的所有设计均来自直正的古典原作, 大部份源自织锦画及其他种类的纺织品。这些设计多是错综复杂的重复图案, 适合各种应用及图案组合, 让您发挥无穷的创意。

CD-ROM及图像的版权

此书的图像可用作图形资源于以使用, 亦可用以启发创作灵感。书中的所有配图均存储在所附的 CD-ROM中, 随时可用于刊物媒体及网页设计上。图像亦可用于制 作纸质或数字化的明信片, 又或是用来装饰阁下的信件、宣传单张及T恤等。这些图像可以直接从CD-ROM输入到多数软件程式中。有些程式可以直接连接到图像; 有些则要求阁下先创设一个文件, 然后才输入图像。详情请参阅阁下的软件手册中的指示。

CD-ROM中的档案名称是跟本书的页码相对应的。CD-ROM随本书附送, 并不得单独出售。The Pepin Press/Agile Rabbit Editions 出版的CD-ROM, 载有的档案相当庞大, 足以应付多数应用。不过, 本社亦提供更大及/或矢量格式化的档案, 请到The Pepin Press/Agile Rabbit Editions 选购。

单个图像可于非专业用途上免费使用。但在未经The Pepin Press/Agile Rabbit Editions事先许可的情况下, 图像不能用于任何类型的商业或其他专业用途, 当中包括所有类型的打印或数字化的刊物。本社订有一套合理的许可政策。若有收费的需要, 所涉的金额亦通常是甚低微的。

有关许可及收费, 请联系:
mail@pepinpress.com
传真: +31 20 4201152

序文

本書と付録CD-ROMでは、中世、ルネサンス、およびバロック時代の「繰り返し模様」を紹介しています。初期のデザインには、犬や鹿などの家畜または狩猟に関連する動物や、一角獣のような伝説上あるいは想像上の生物が施されています。それ以降では、主に花柄が用いられました。また、すべての年代にまたがった、さまざまな幾何学模様も紹介しています。

タペストリーやその他繊維製品から、各時代特有の模様を厳選しました。繰り返し模様には、複雑で完成度の高いものが多く、さまざまな場面で利用できます。

CD-ROM及びイメージの著作権について

本書に掲載されているデザインは、グラフィック・デザインの参考にしたり、インスピレーションを得るための材料としてご使用ください。本書に掲載されているすべてのイラストは、附録のCD-ROMに収録されています。印刷媒体やウェブデザイン、絵はがき、レター、チラシ、Tシャツなどの作成に利用できます。ほとんどのソフトウエア・プログラムへ、CD-ROMから直接インポートが可能です。直接イメージにアクセスできない場合には、まずファイルを作成することで、ご使用になりたいイメージを簡単にインポートできます。インポートの方法などの詳細については、ソフトウエアのマニュアルをご参照ください。

CD-ROMの各ファイル名は、本書のページ番号に対応しています。このCD-ROMは本書の附録であり、CD-ROMのみの販売はいたしておりません。Pepin Press/Agile RabbitのCD-ROM収録のファイルは、ほとんどのアプリケーションに対応できるサイズですが、より大きなサイズのファイル、あるいはベクトル化されたファイルをご希望の方は、The Pepin Press/Agile Rabbit Editions宛てにご連絡ください。

イメージを非営利目的で一度のみ使用する場合は無料です。印刷媒体、デジタル媒体を含む、業務や営利目的でのご使用の場合は、事前にThe Pepin Press/Agile Rabbit Editionsから許可を得ることが必要です。著作権料が必要となる場合でも最小限の料金でご提供させていただきます。

使用許可と著作権料については下記にお問い合わせください。
mail@pepinpress.com
ファックス：31 20 4201152

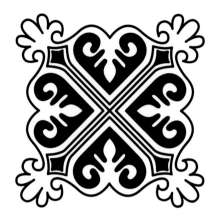

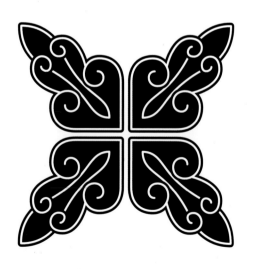

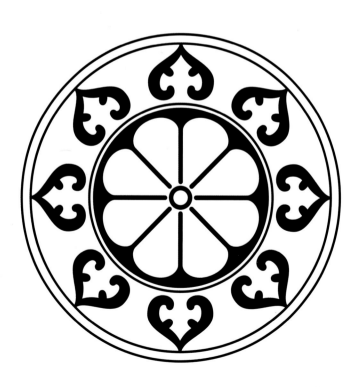

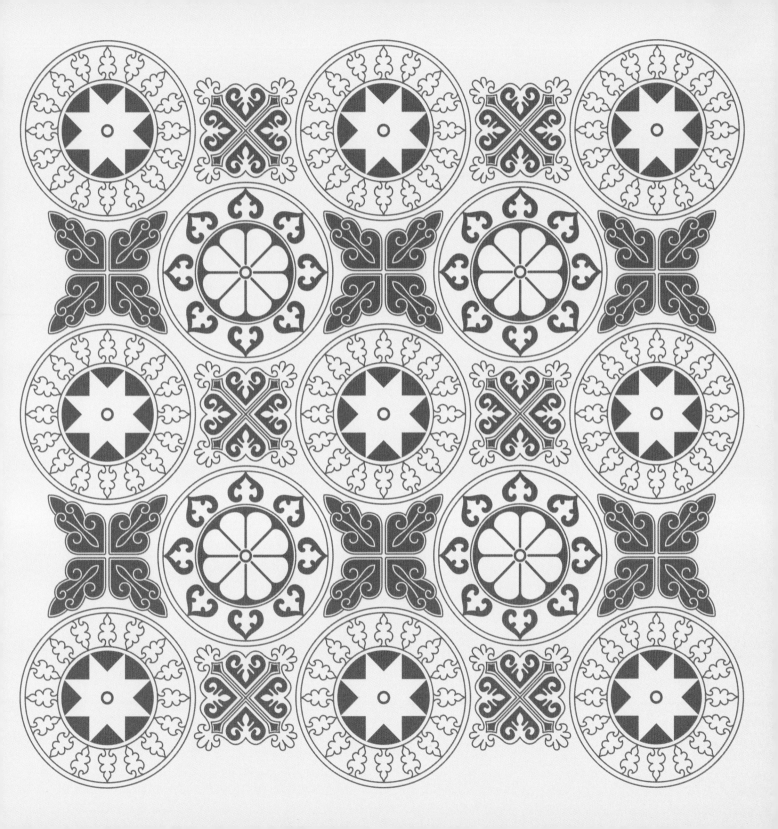

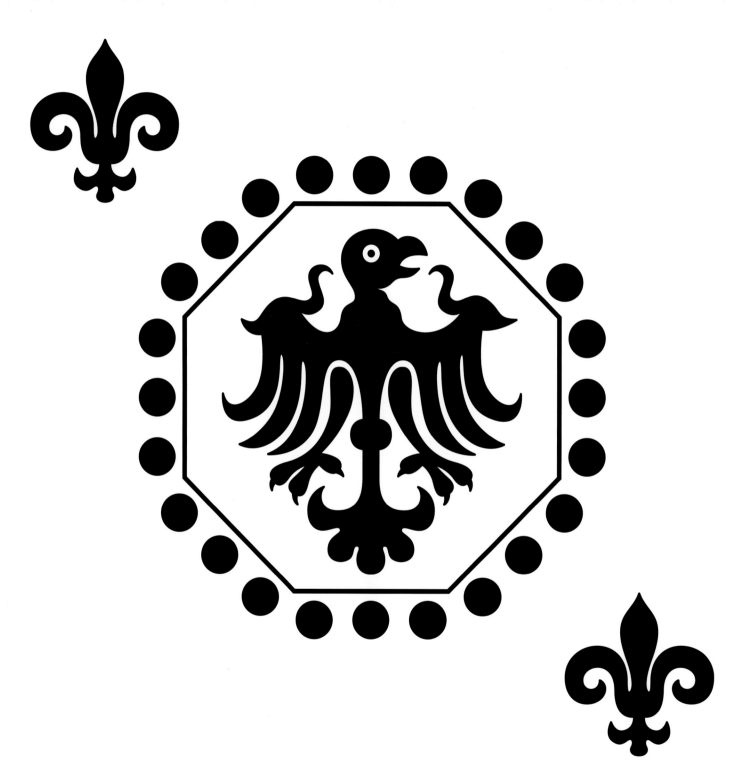

24

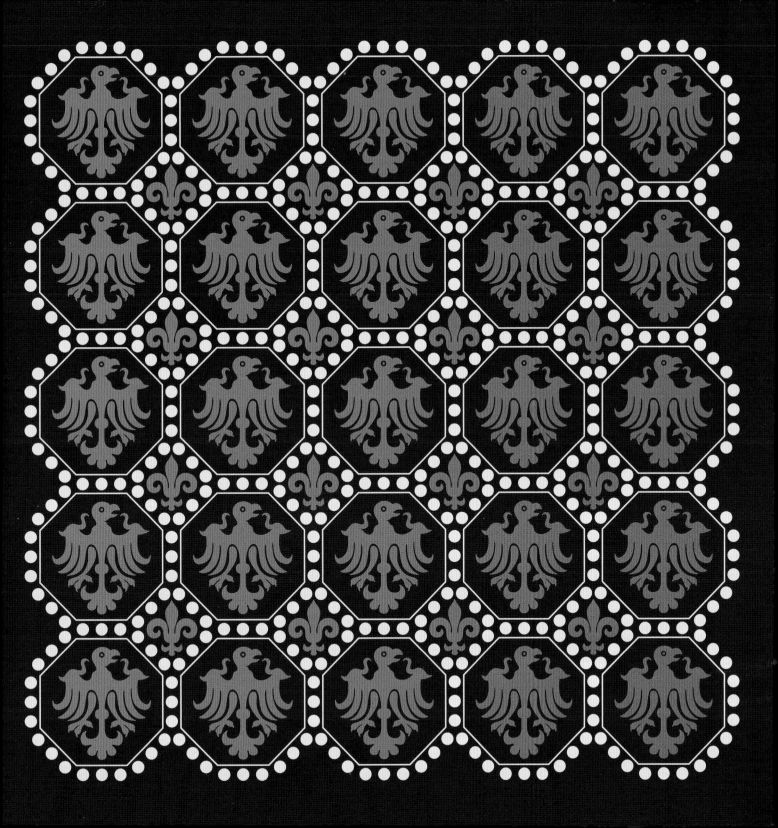

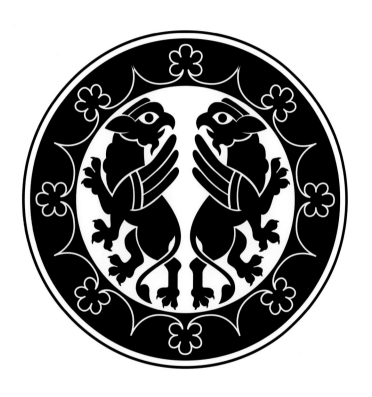

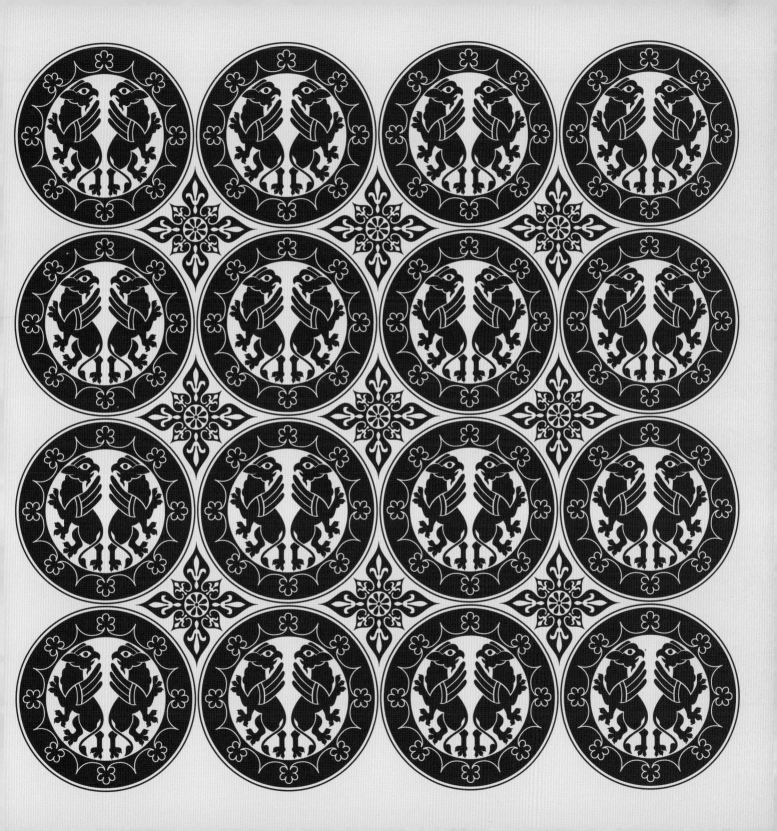

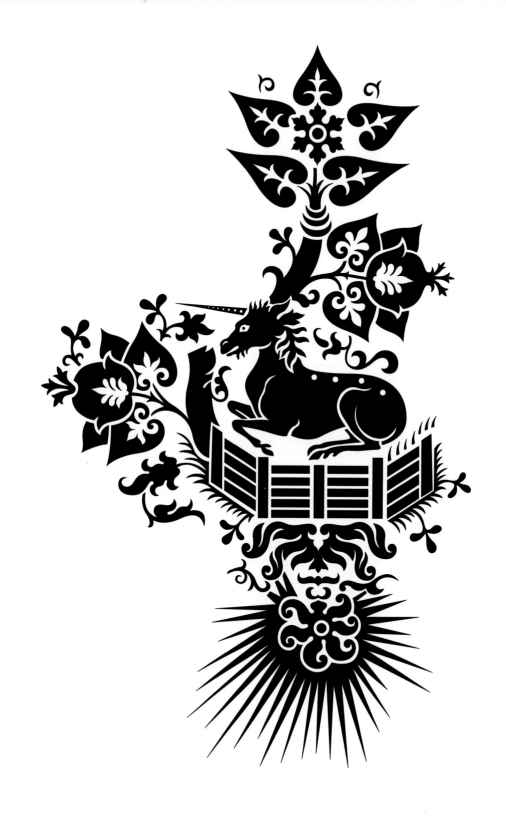

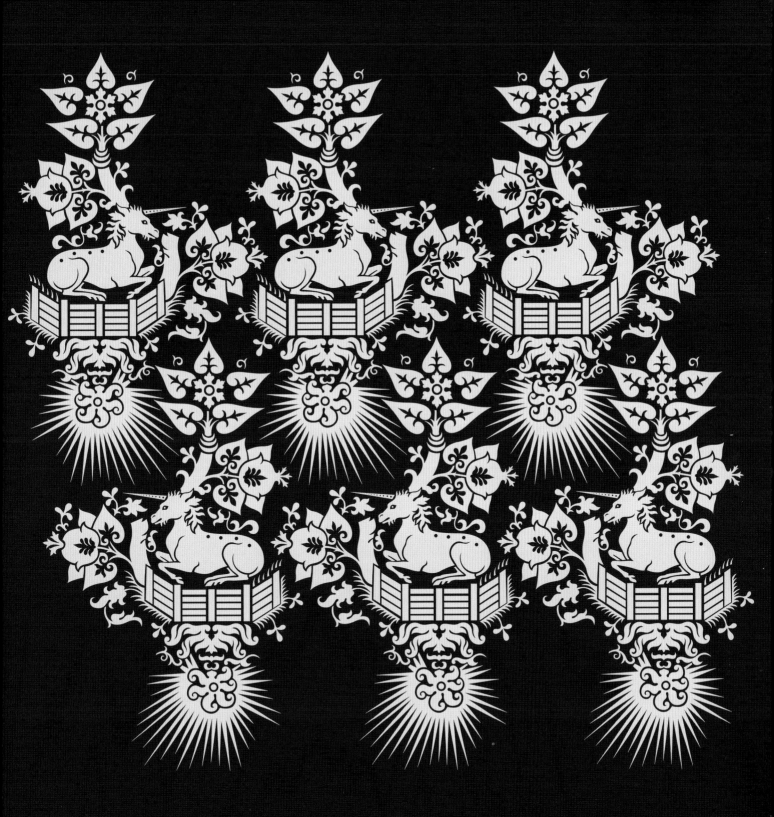

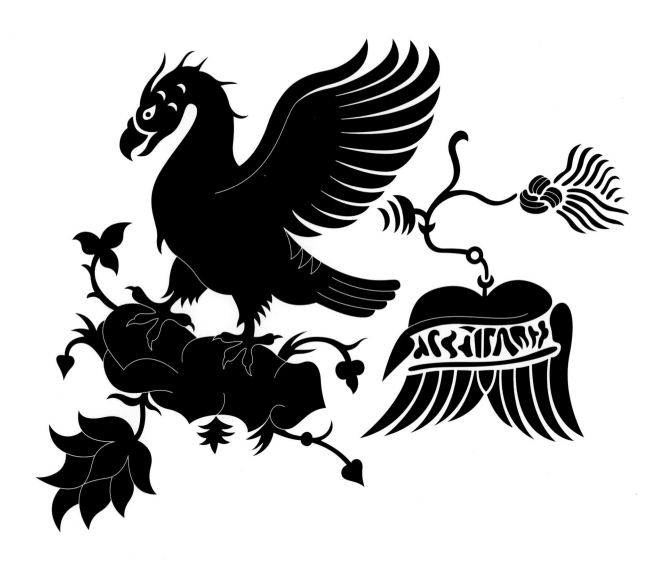

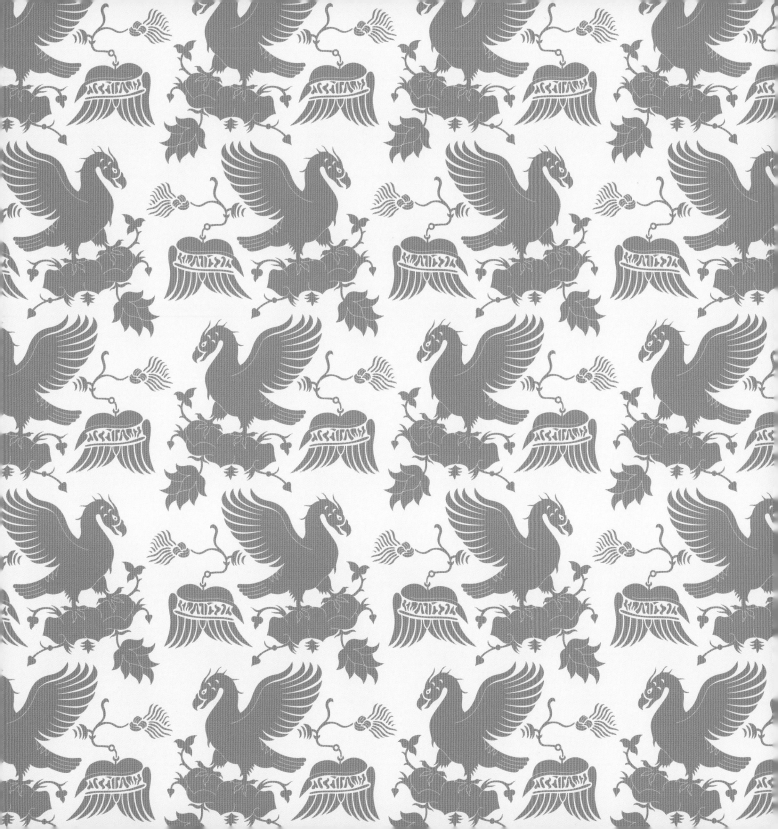

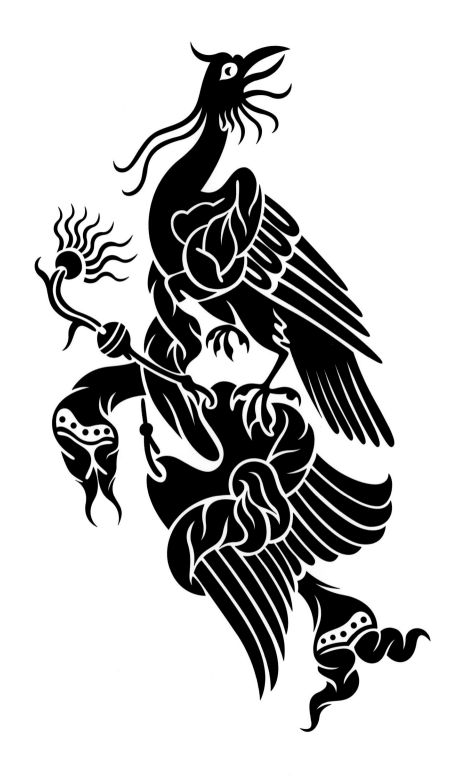

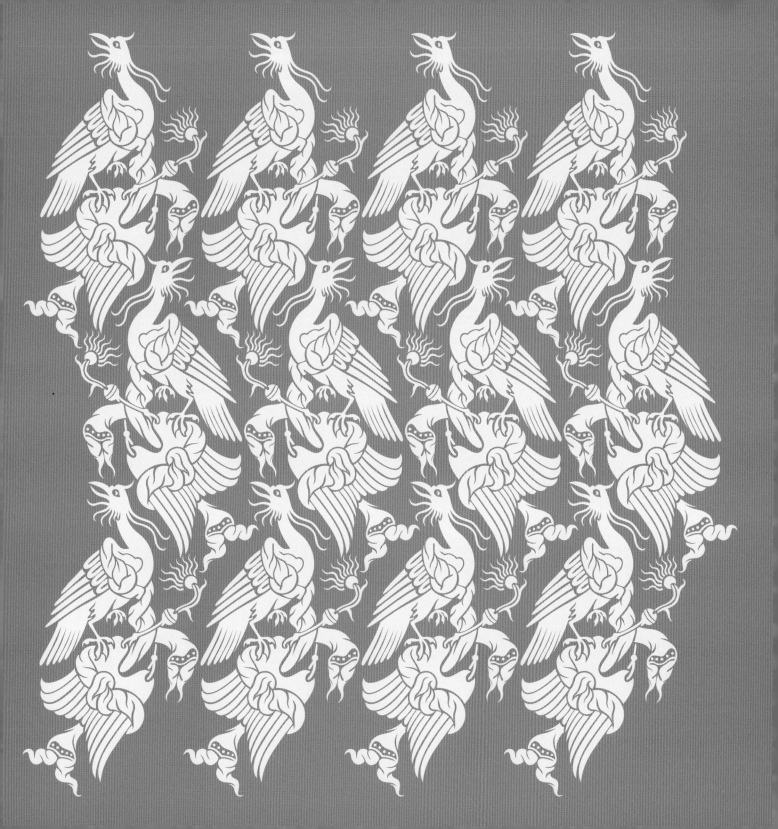

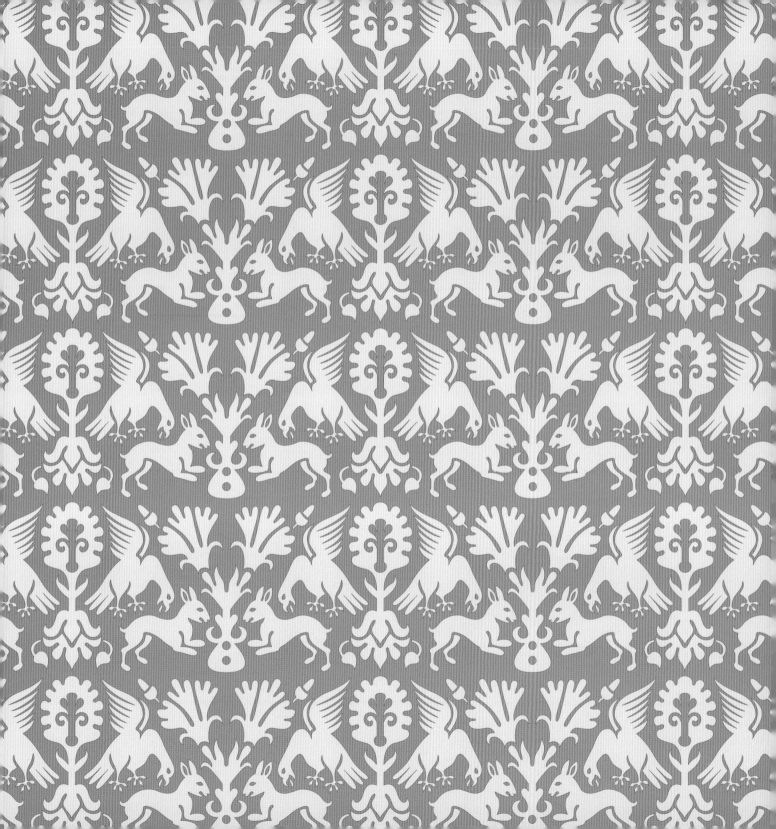

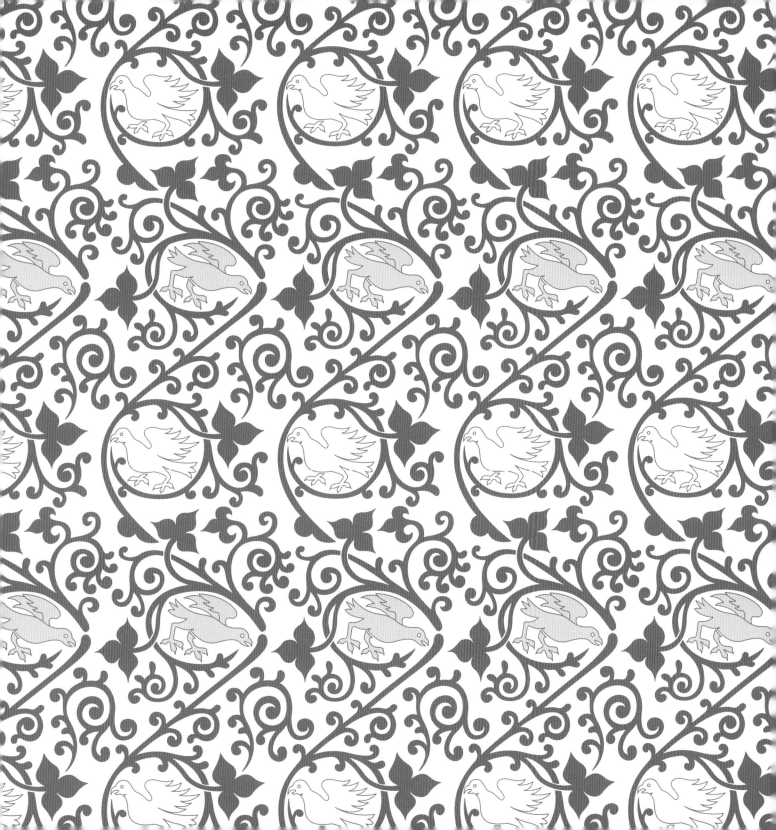

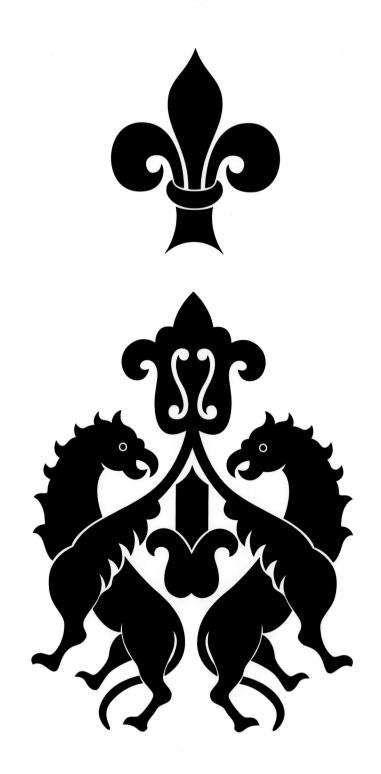

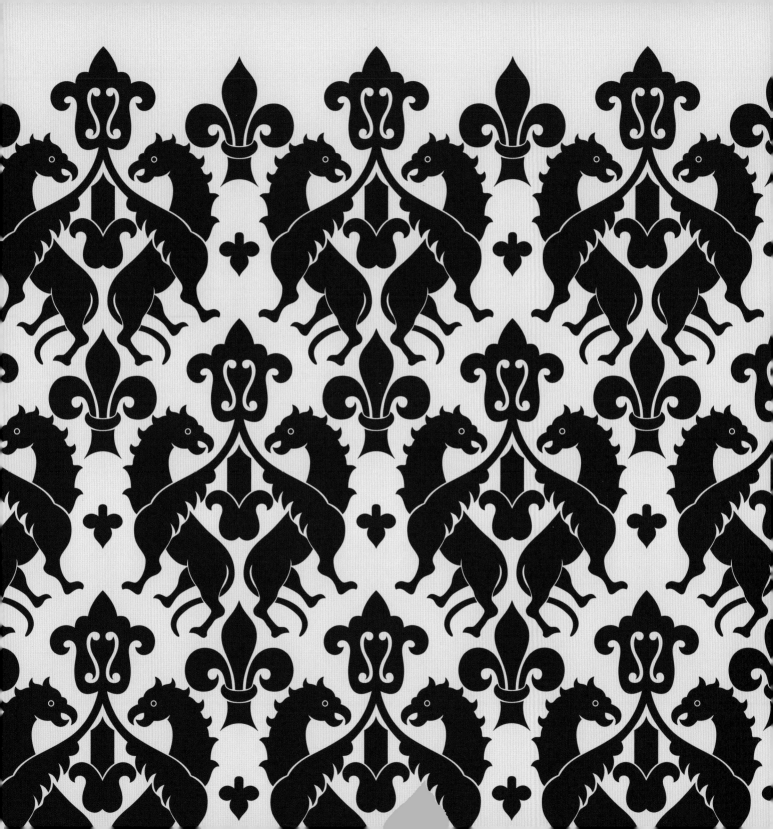

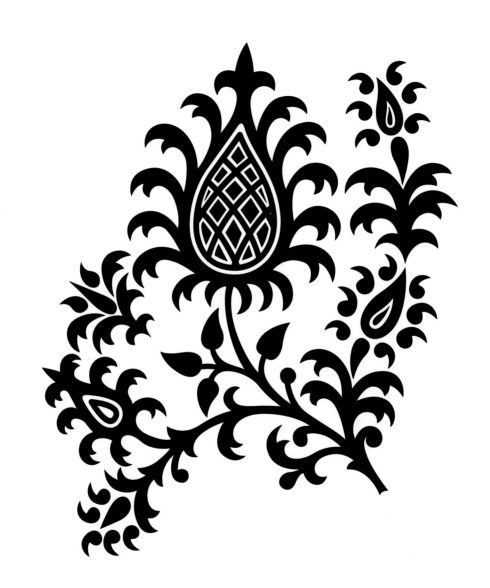

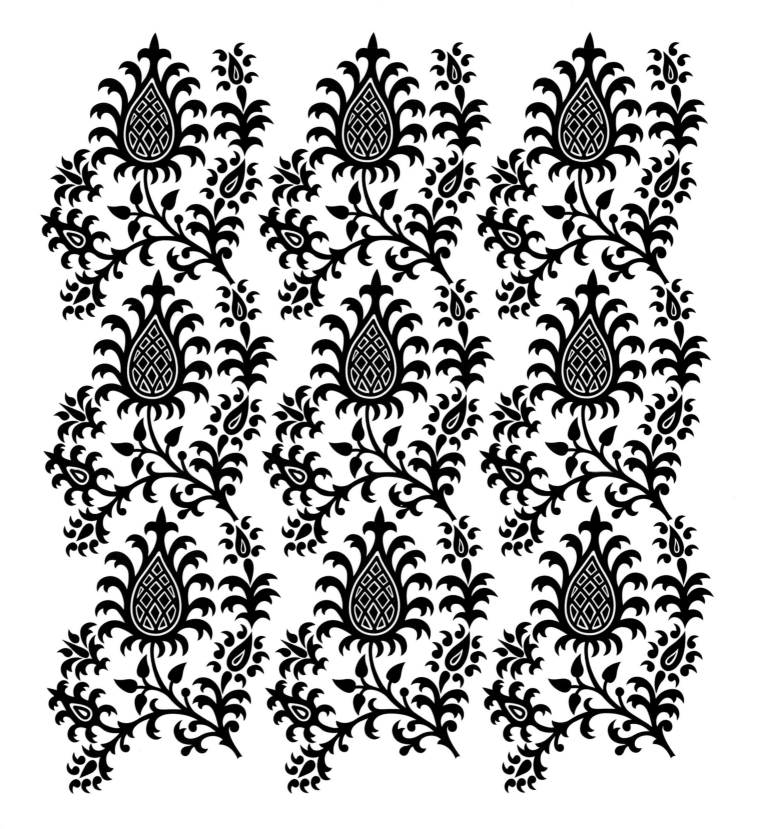

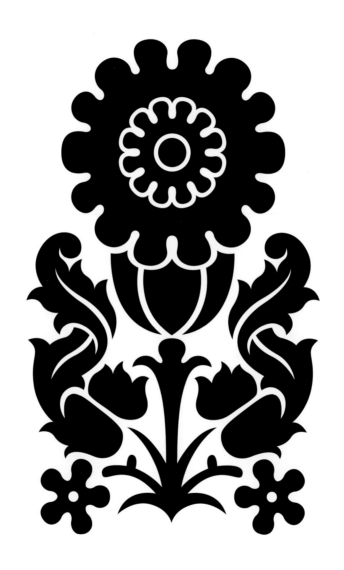

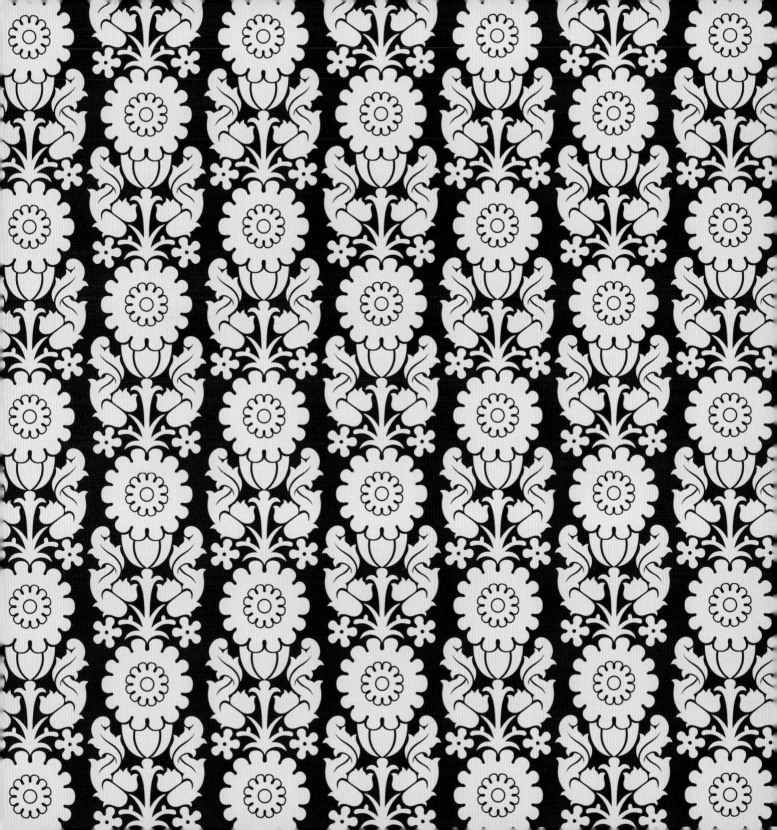

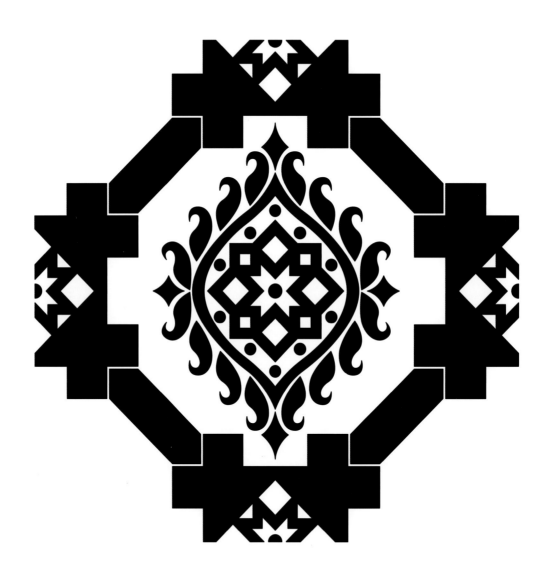

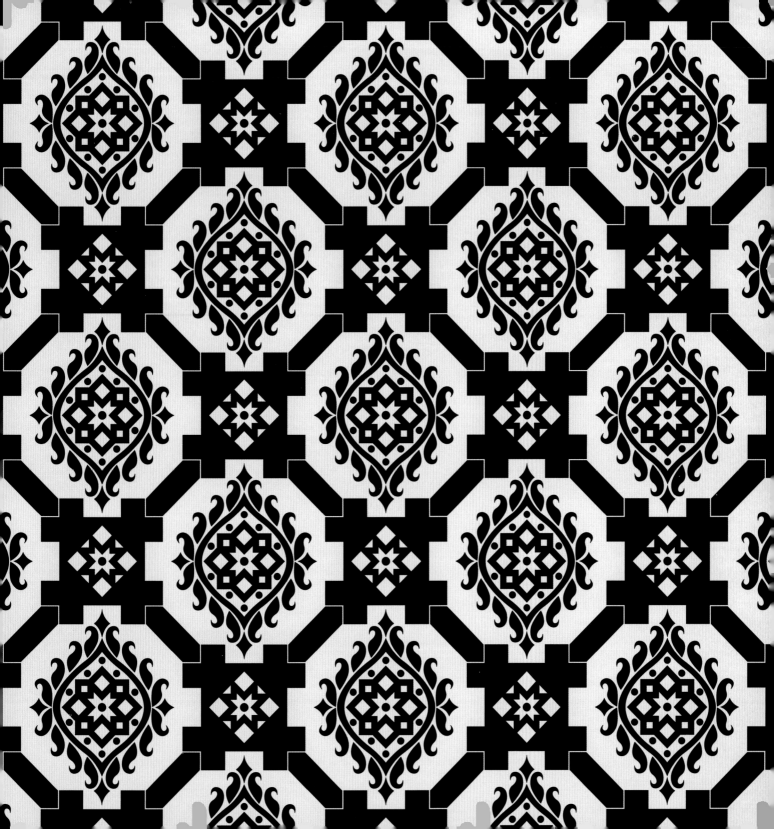

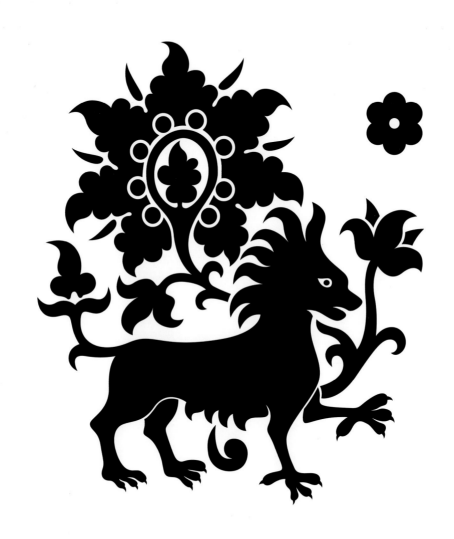

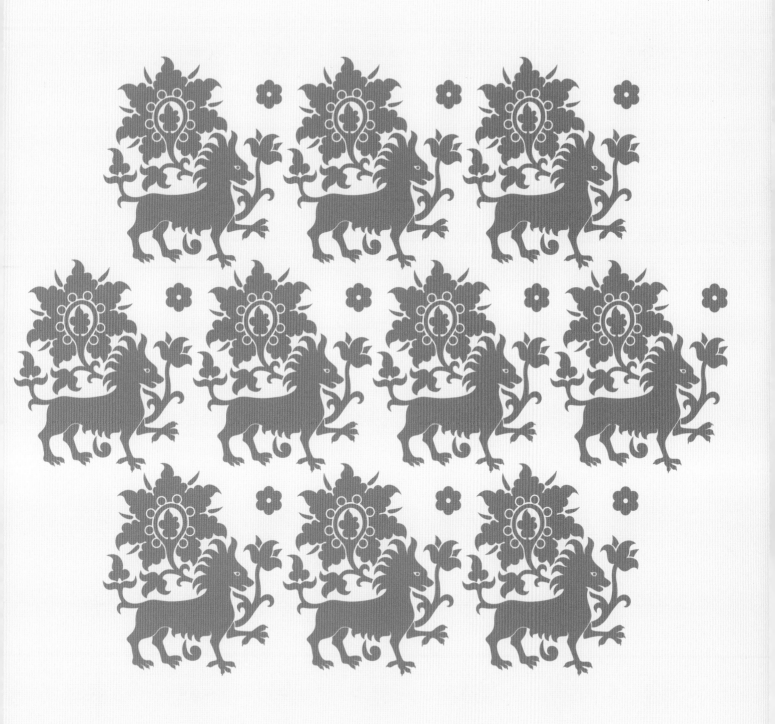

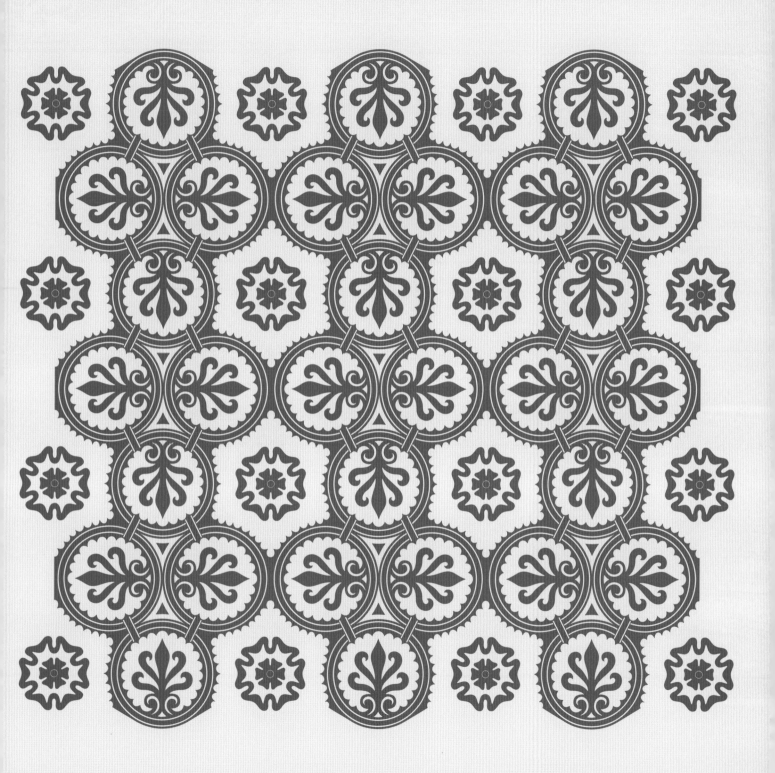

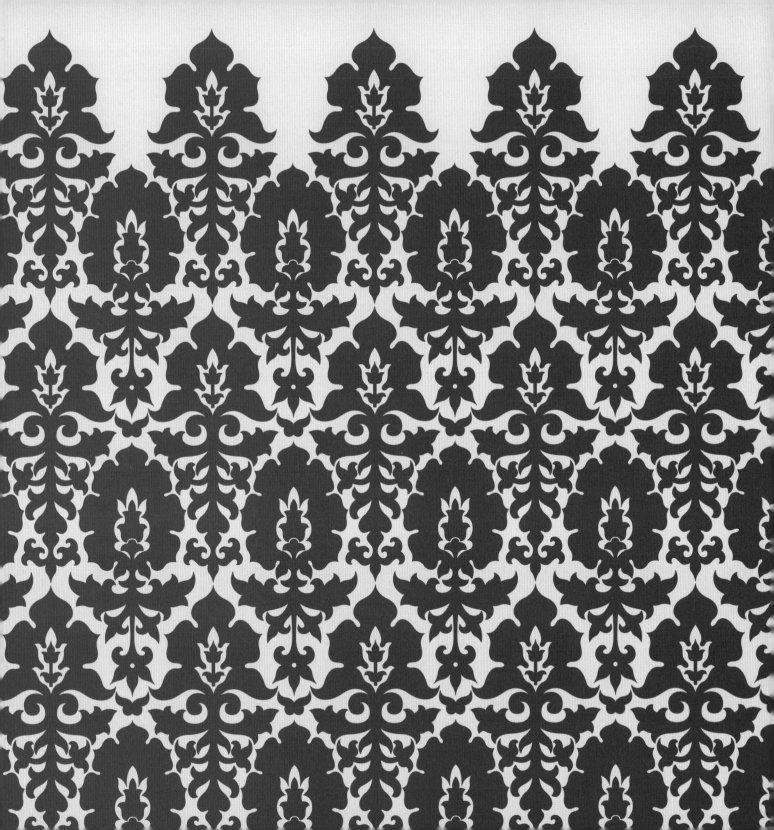

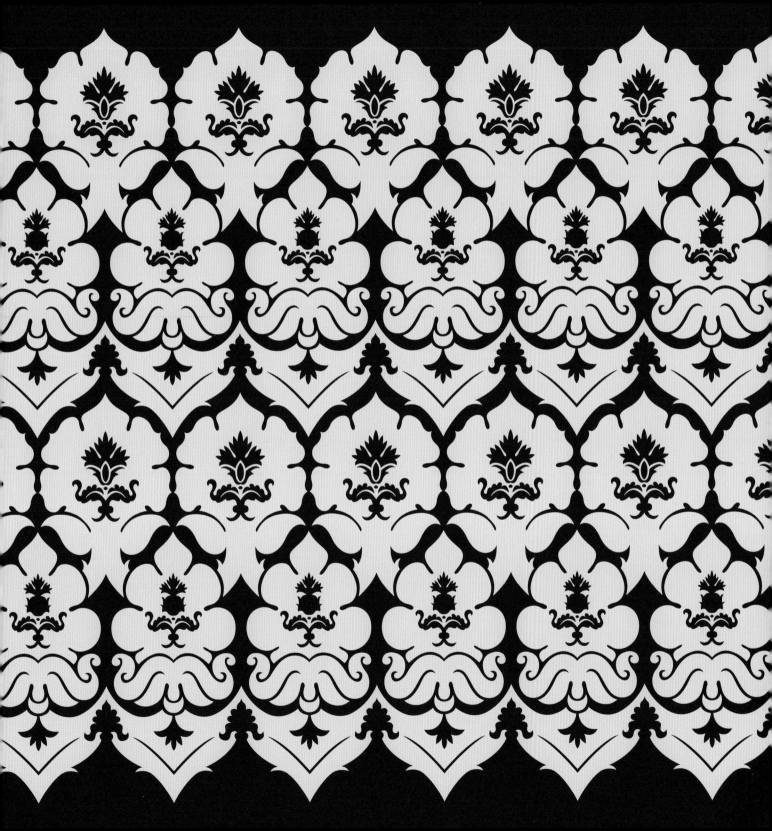

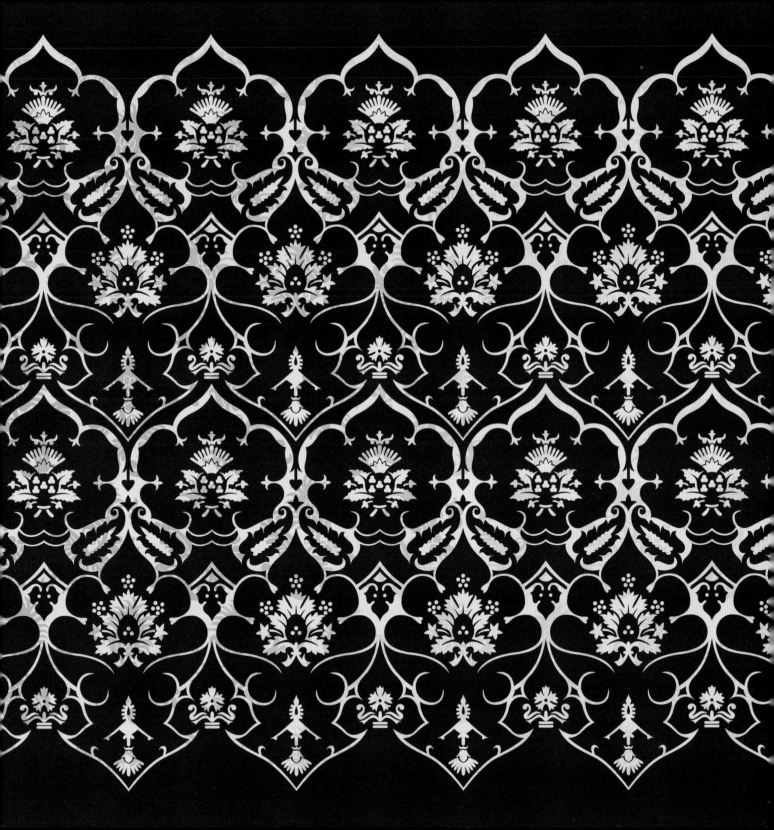

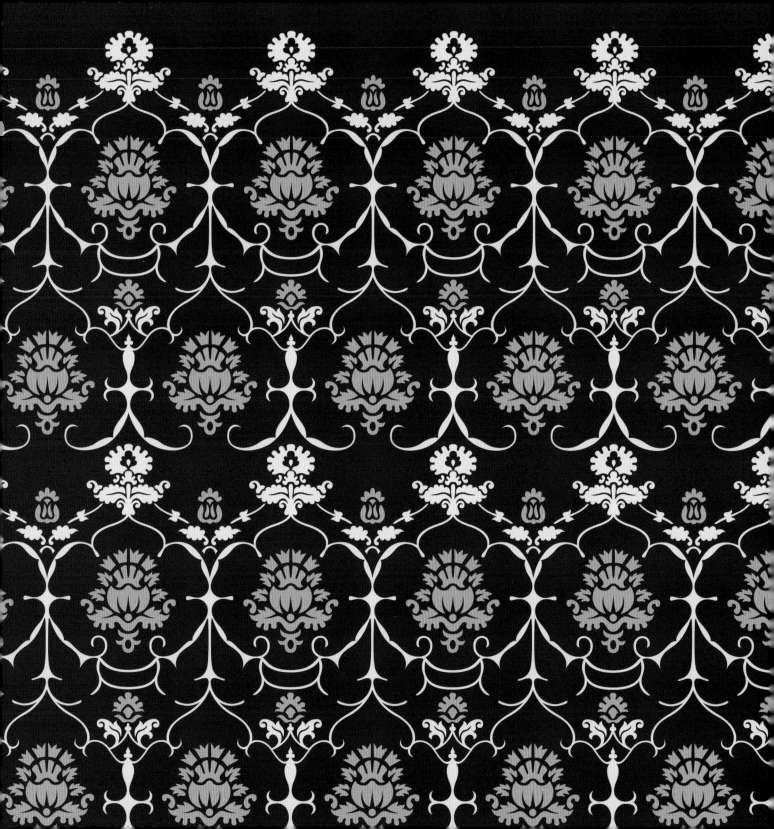

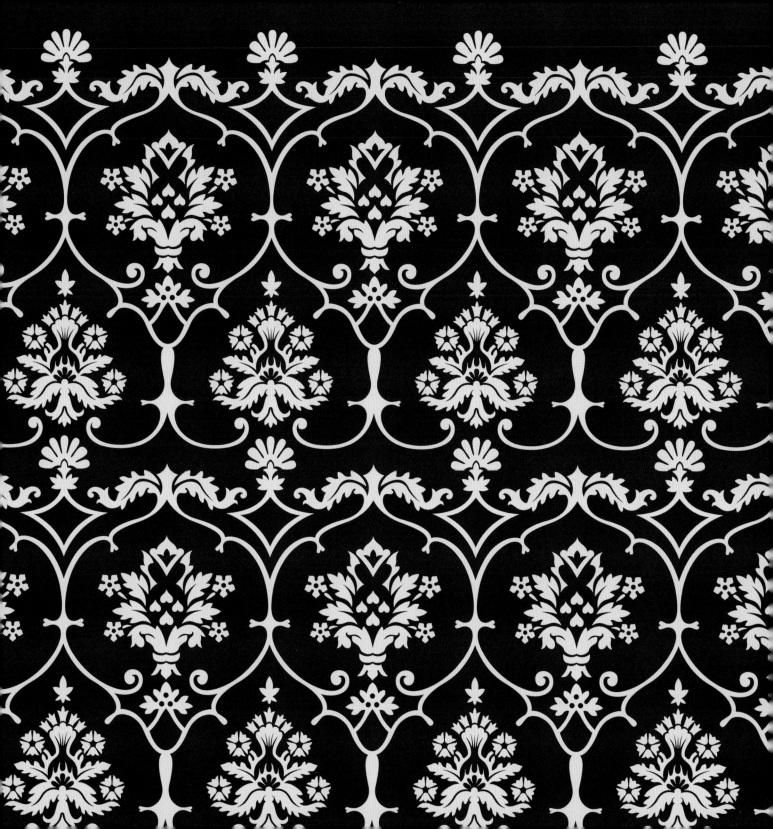

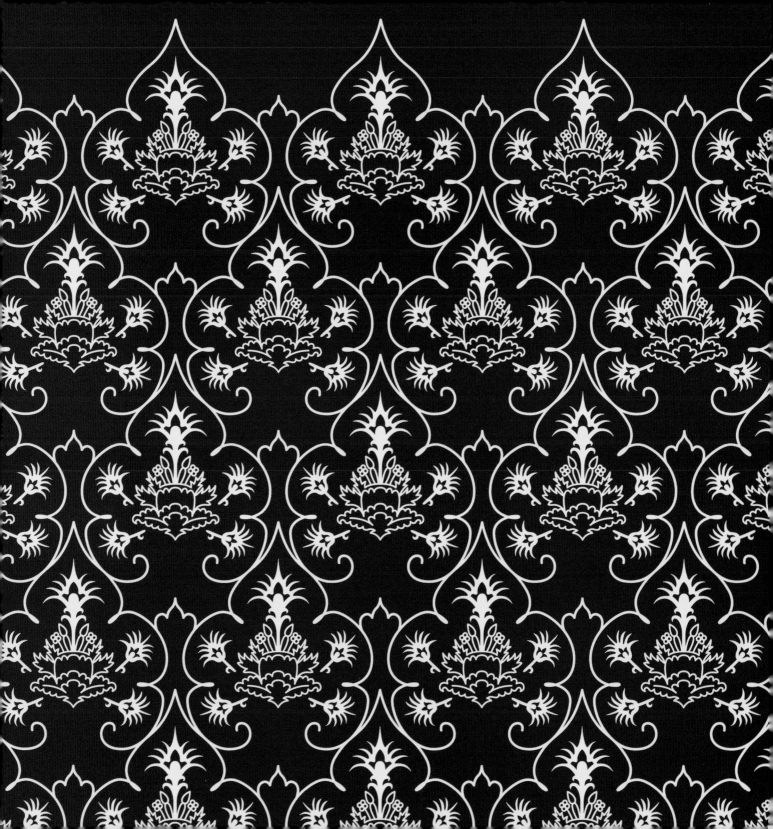

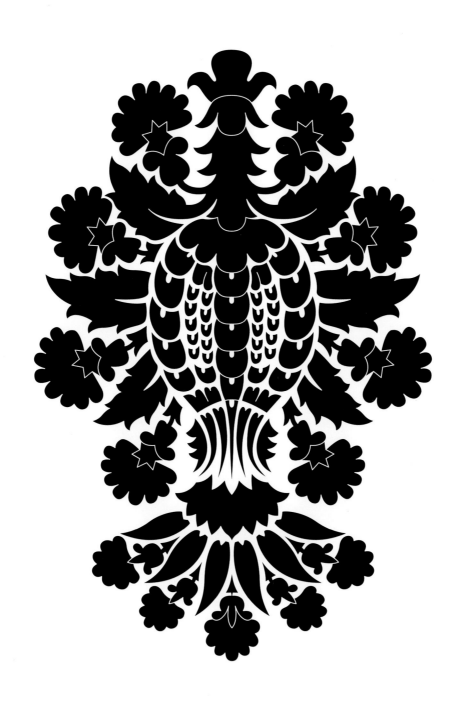

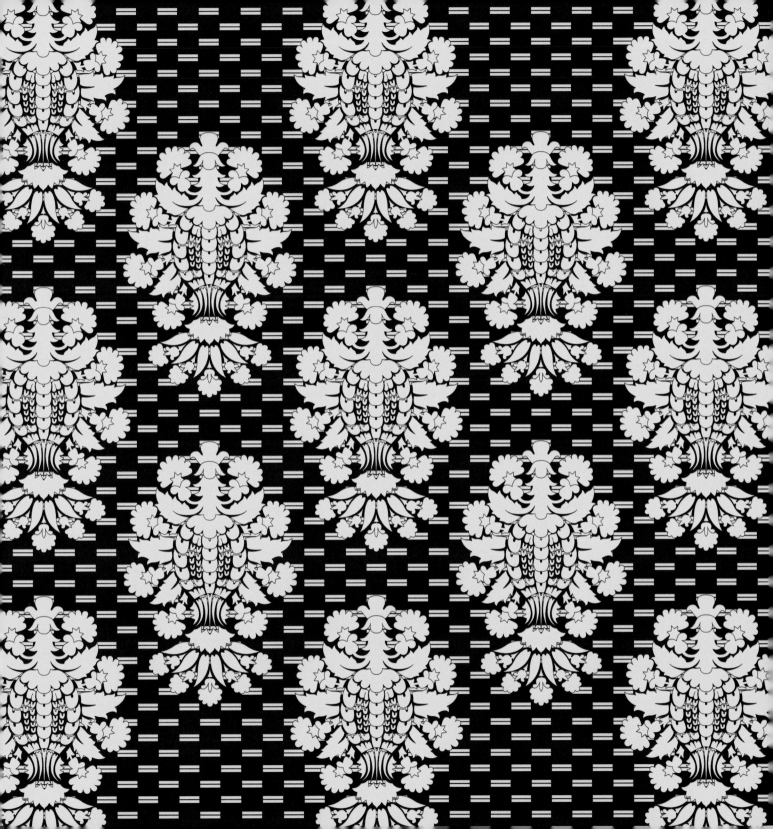

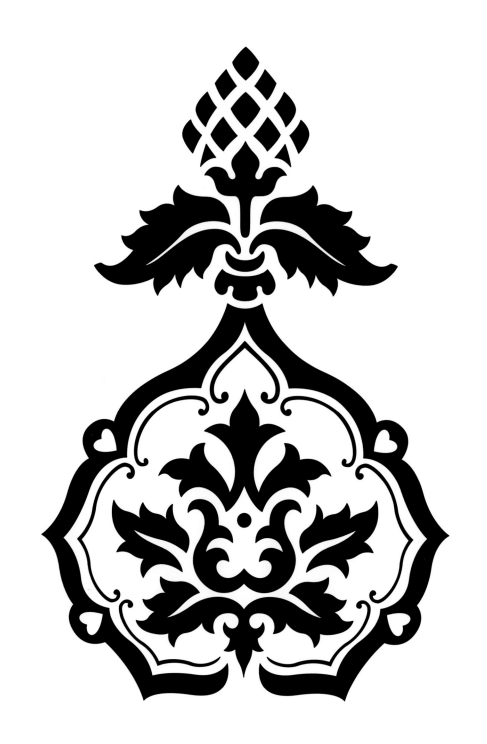

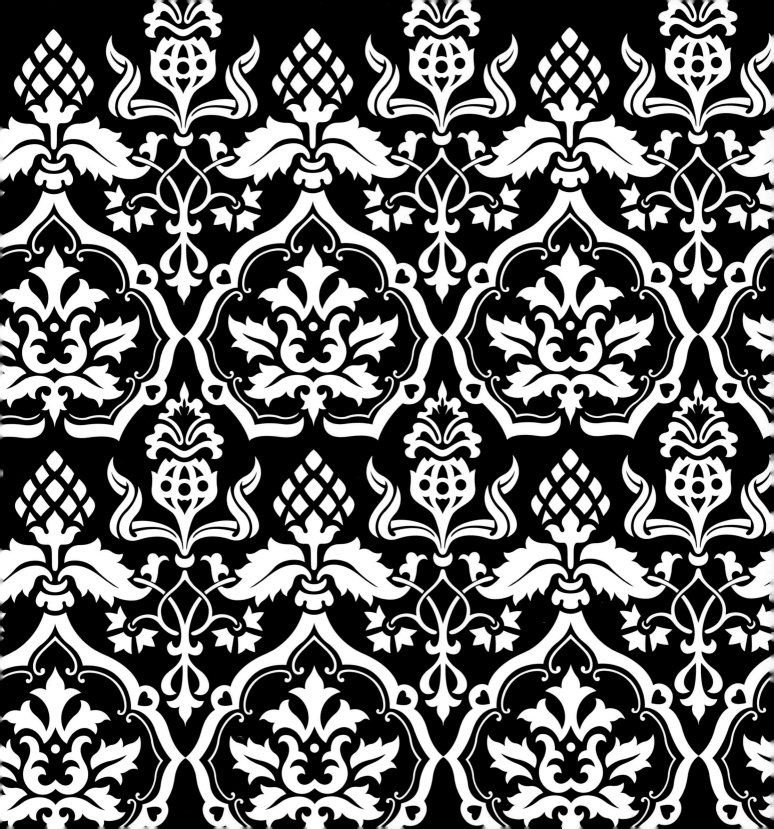

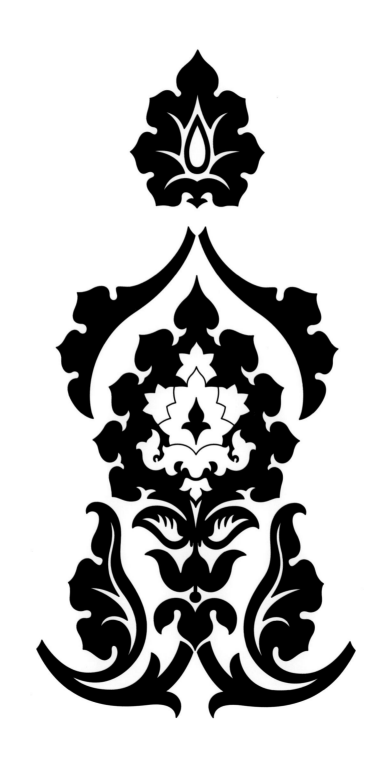

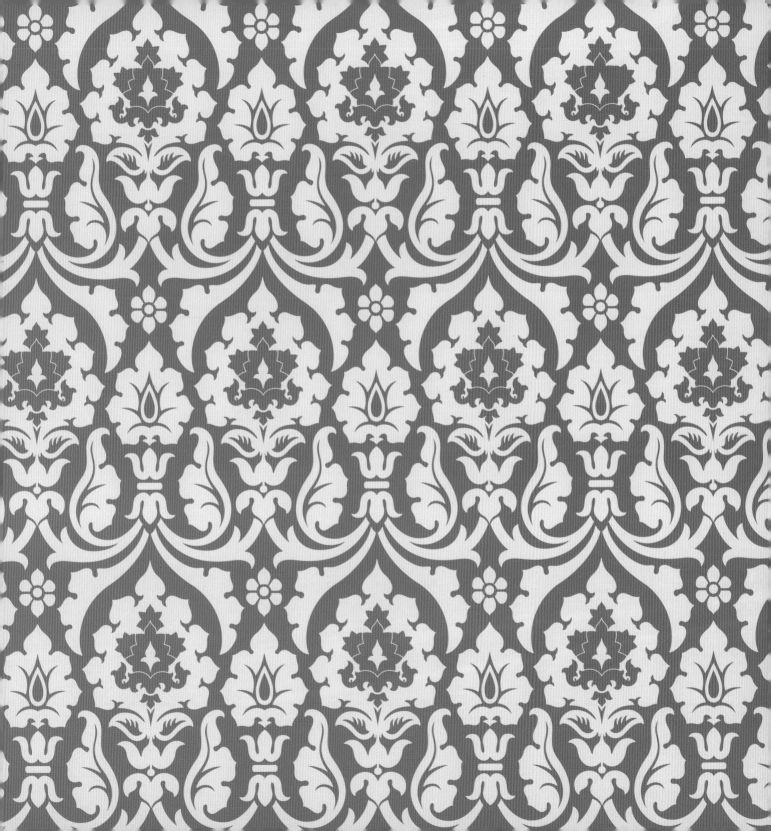

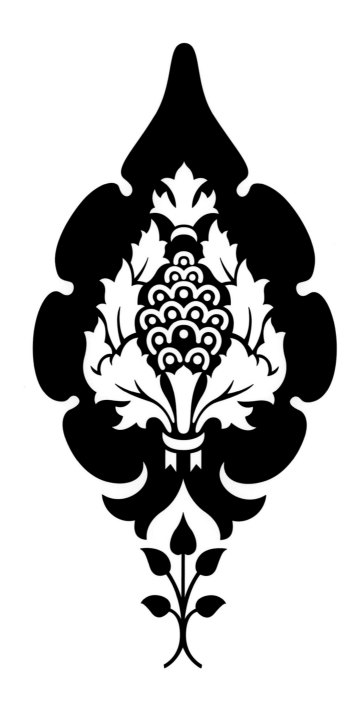

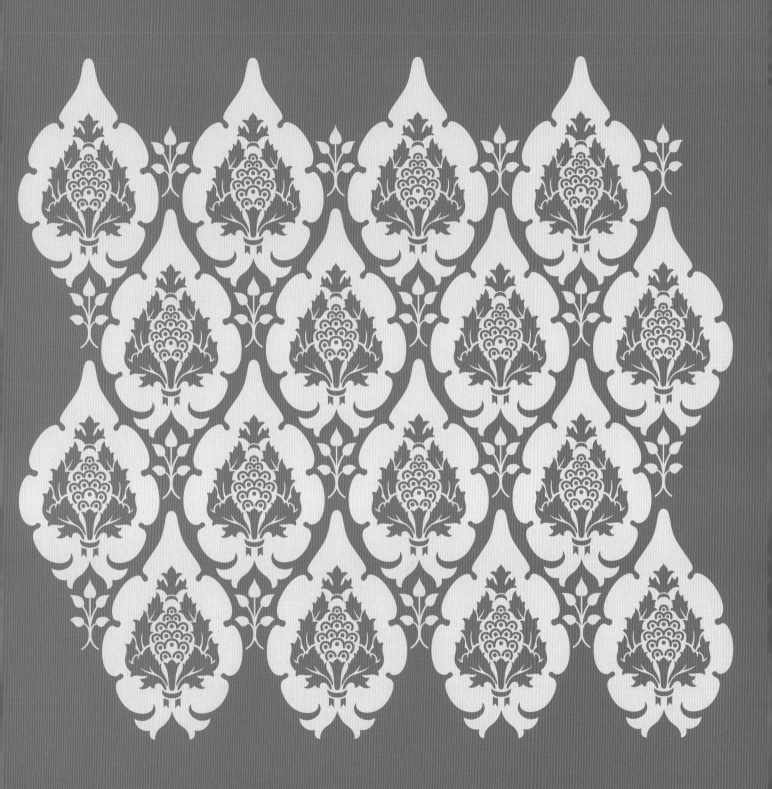

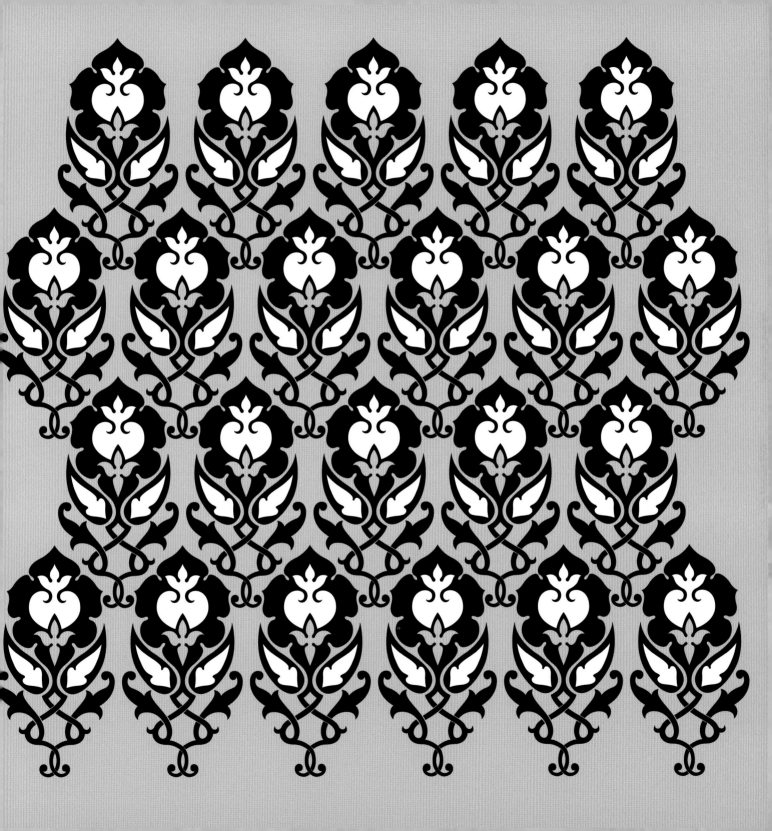

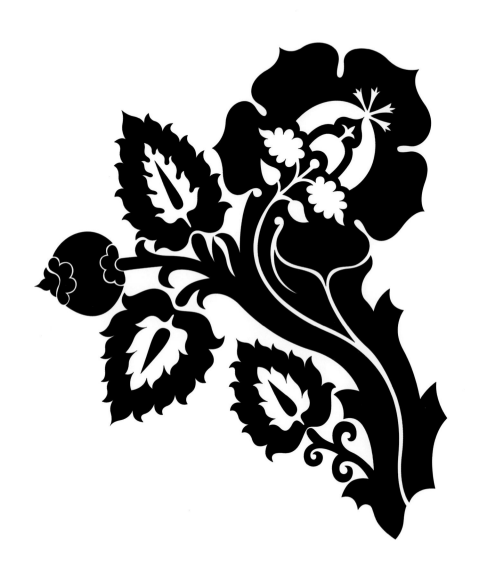

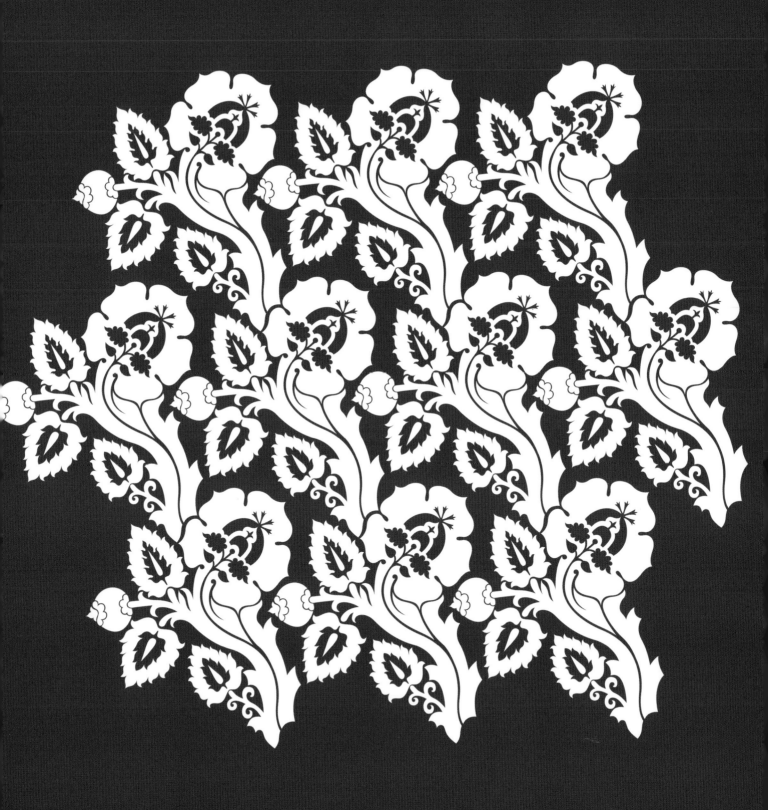

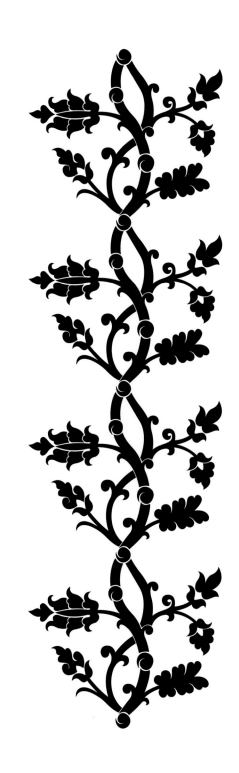

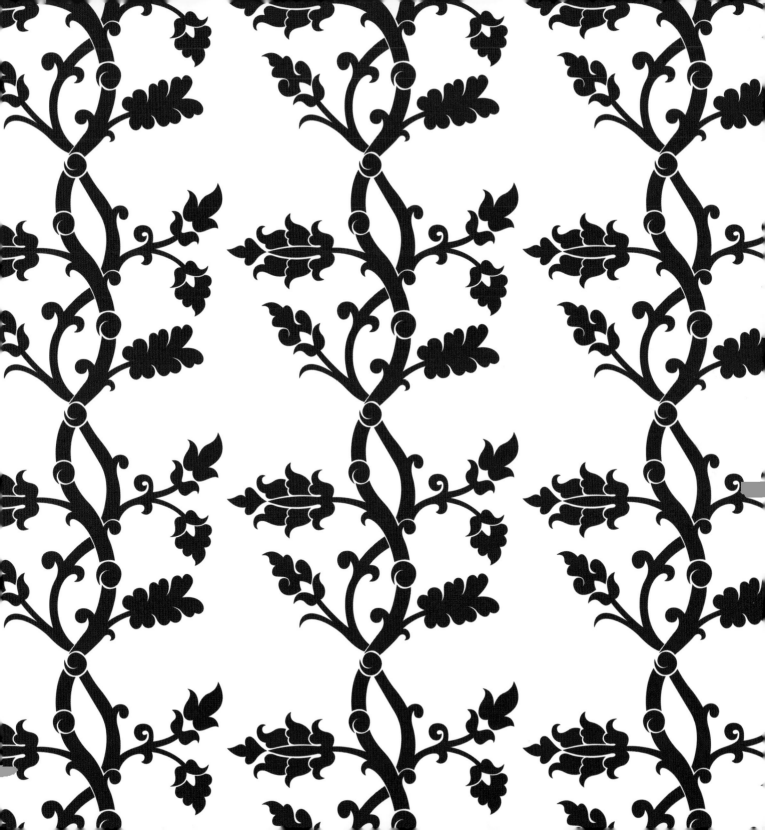

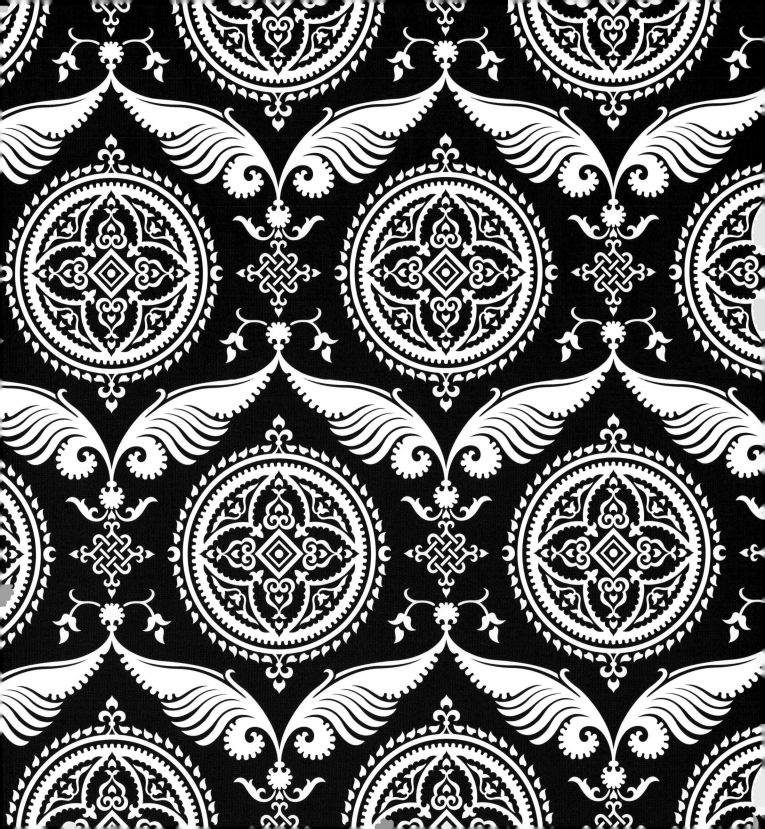

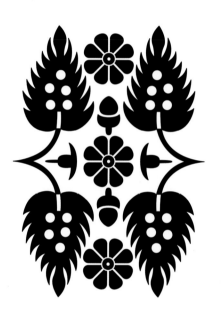

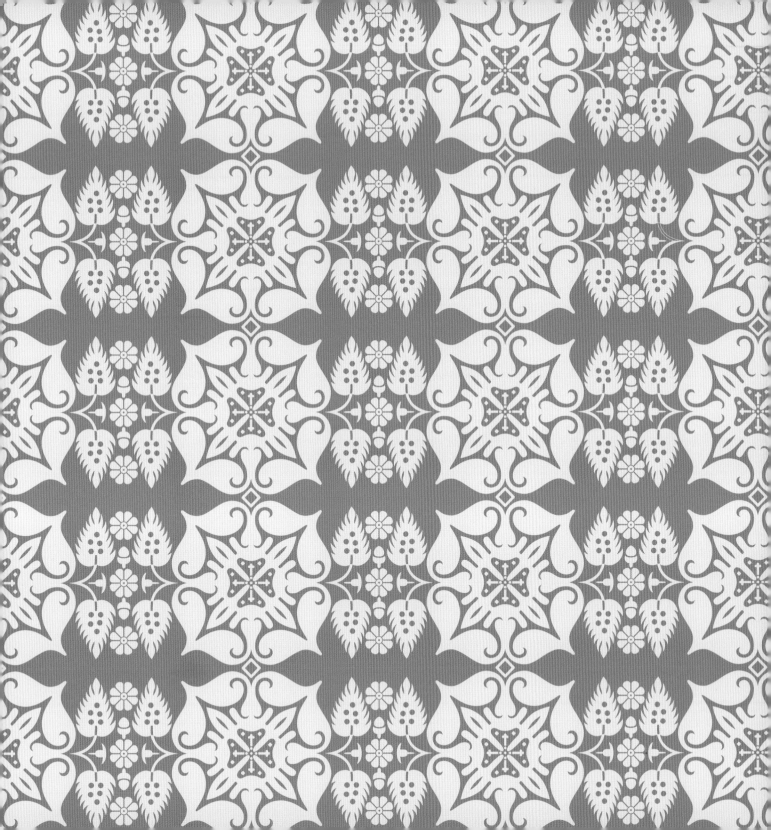

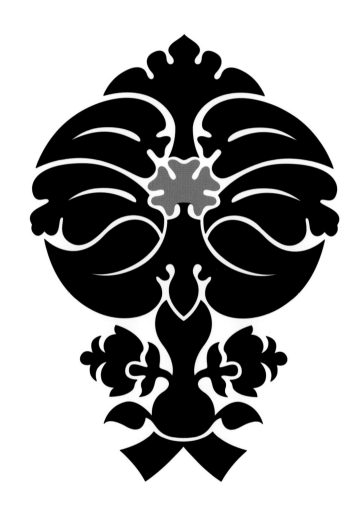

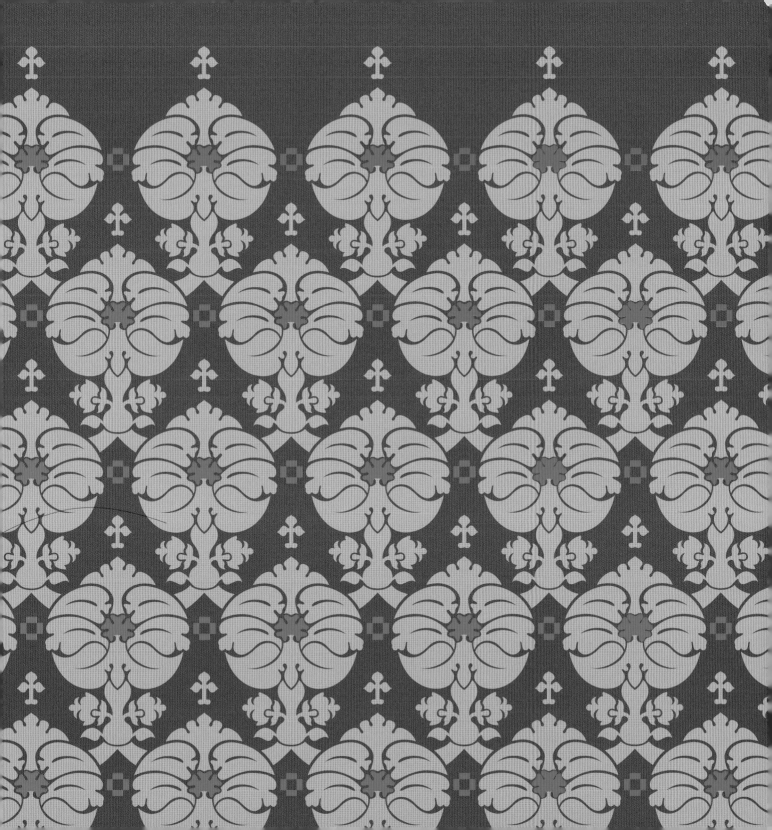

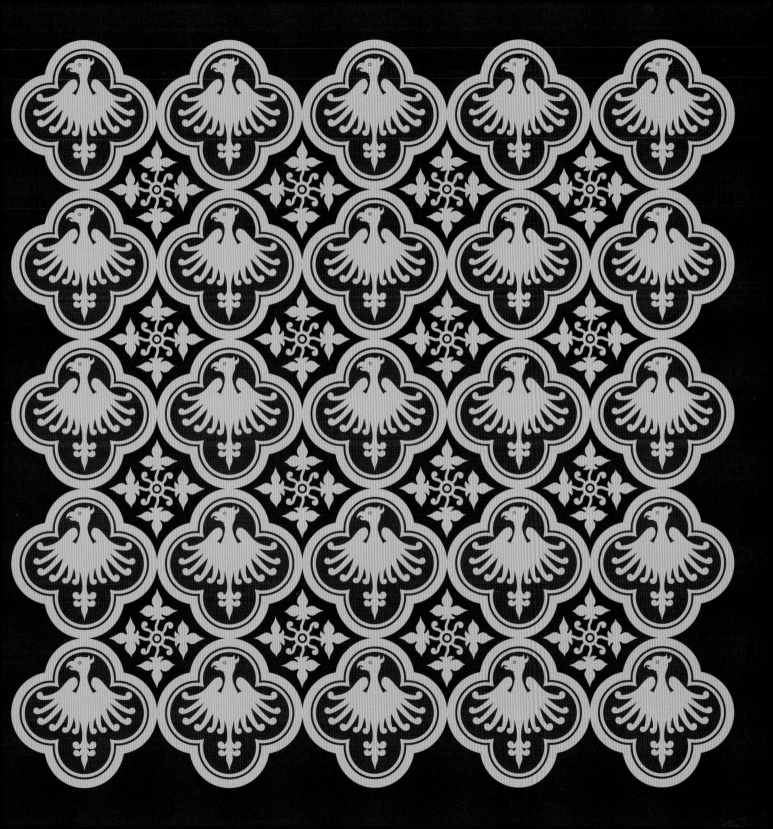

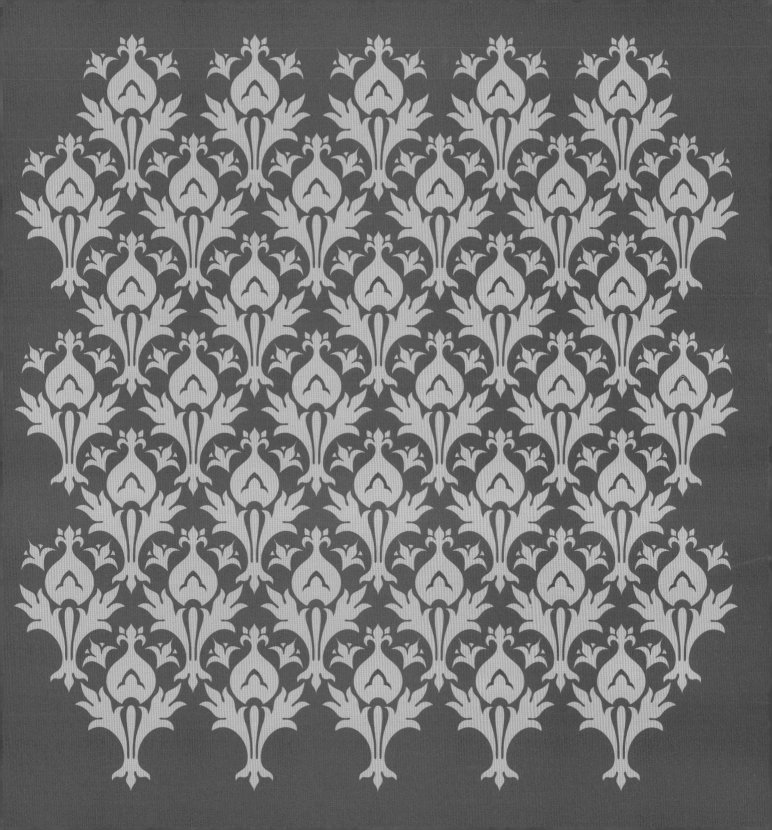

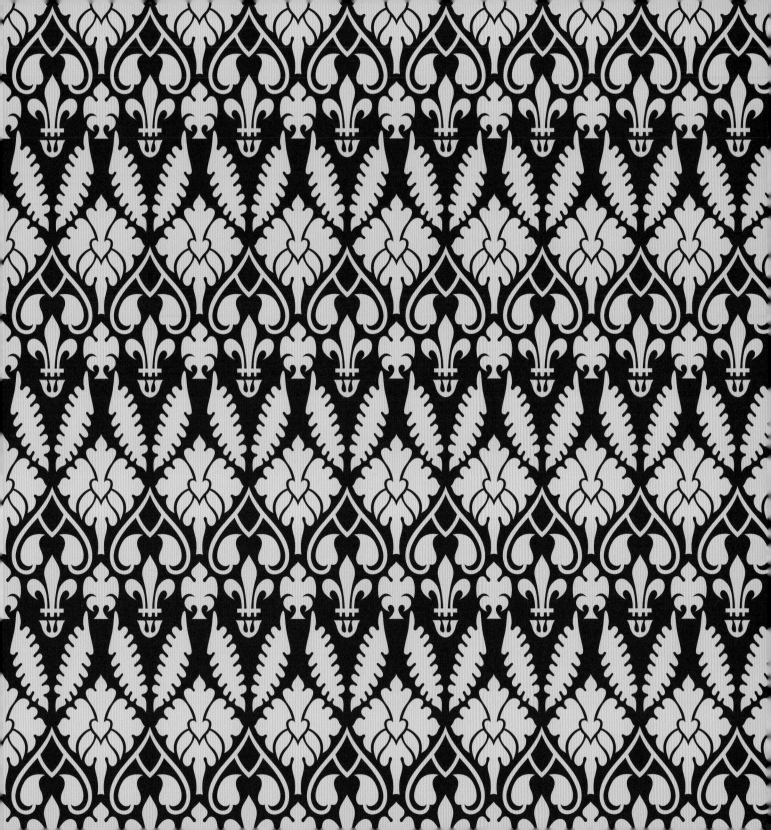

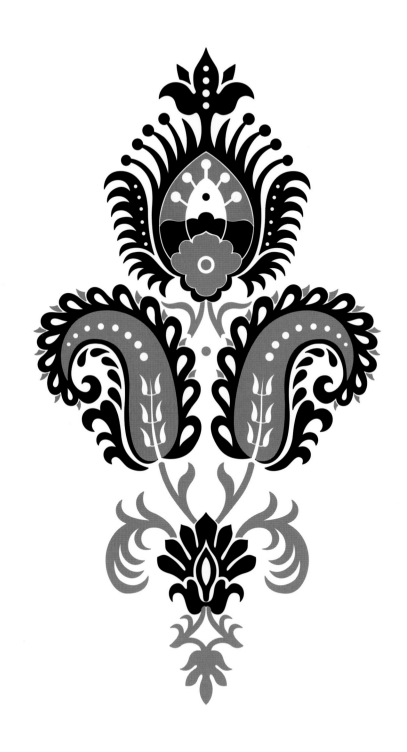

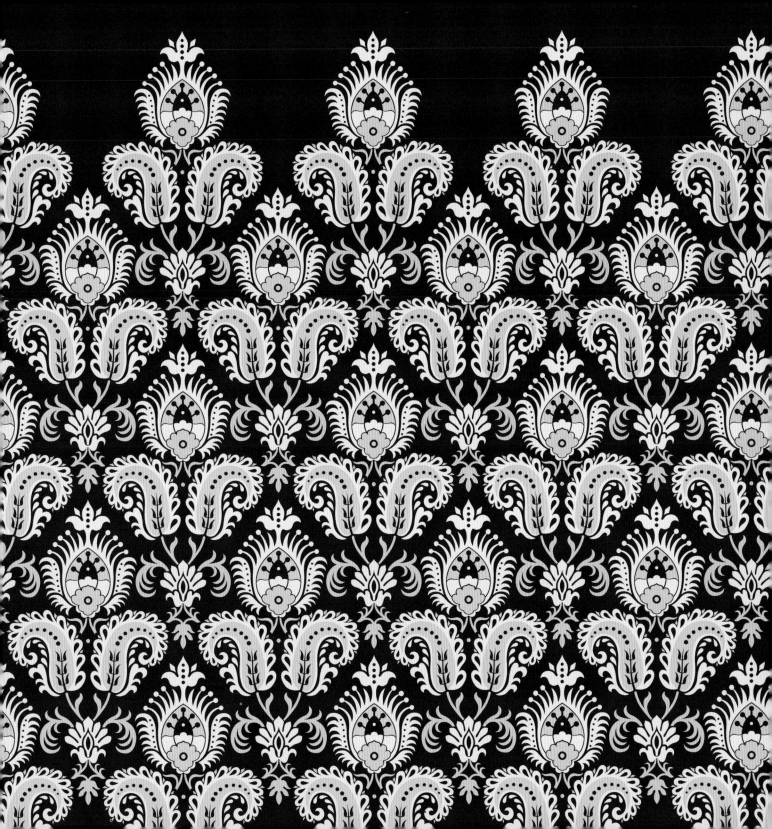

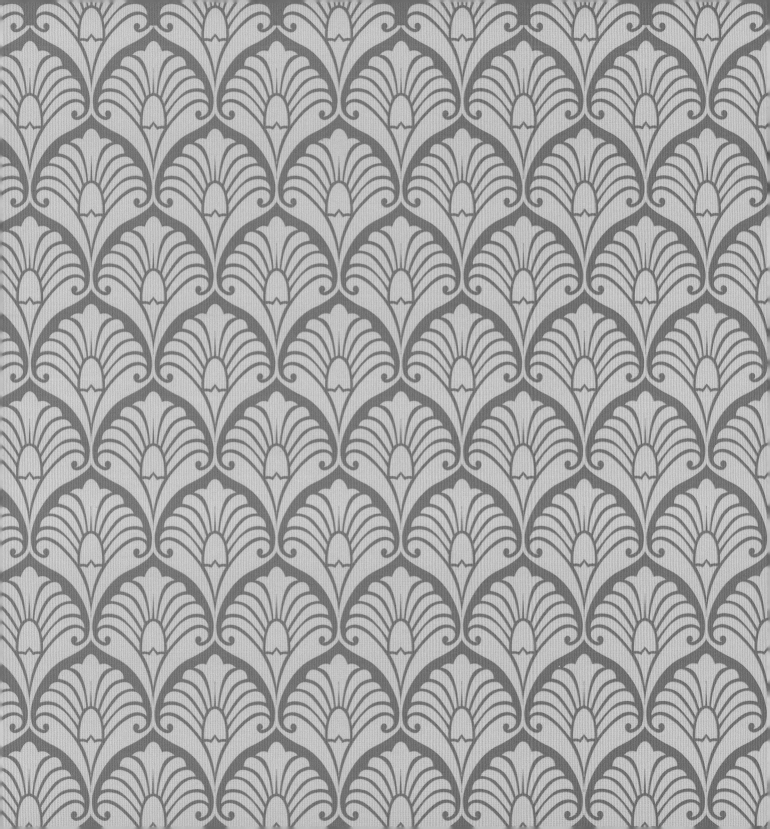

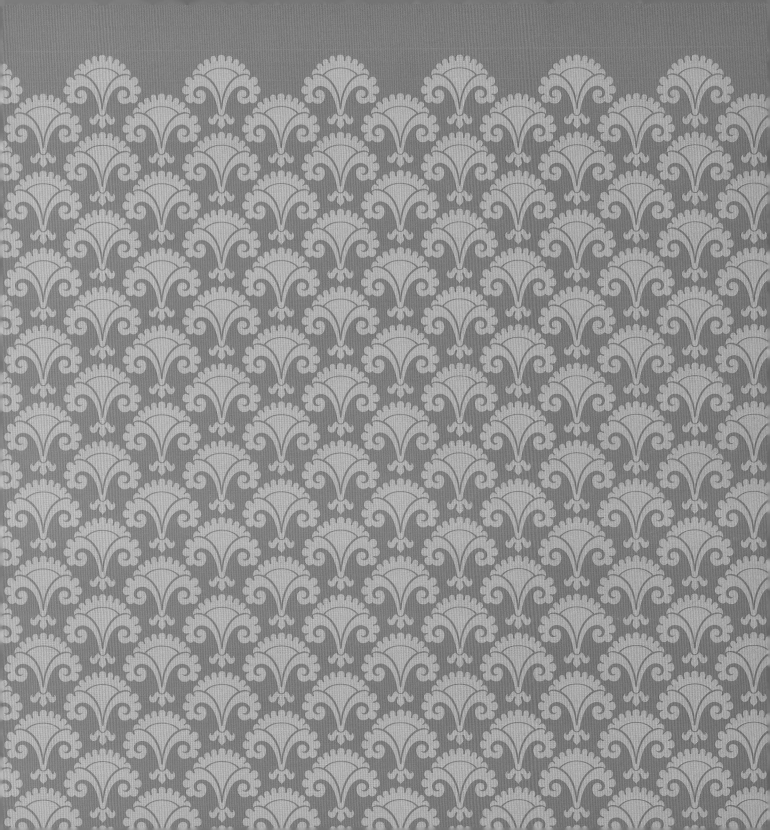

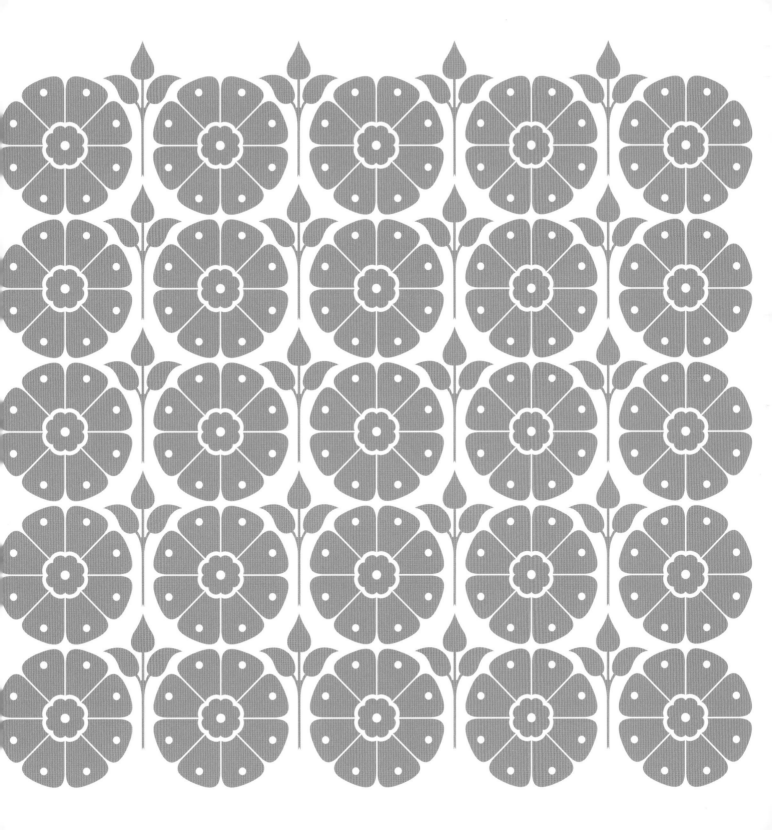

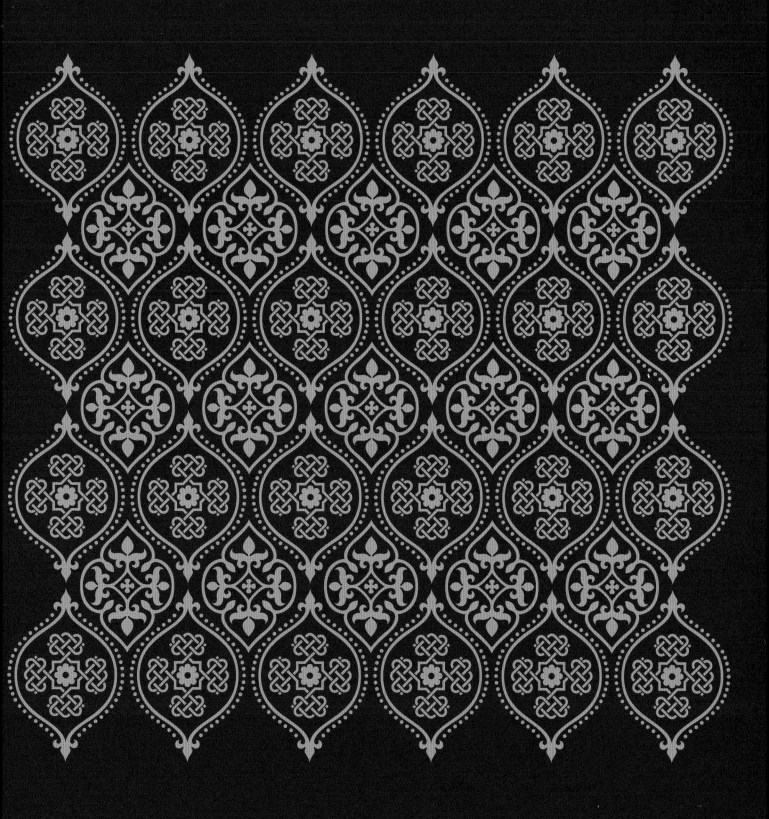

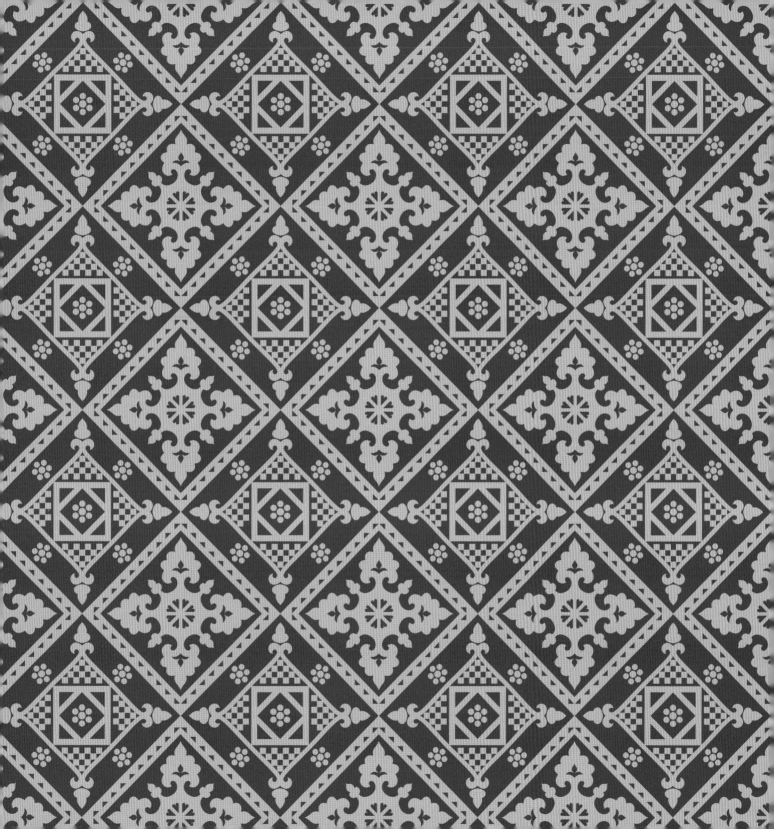

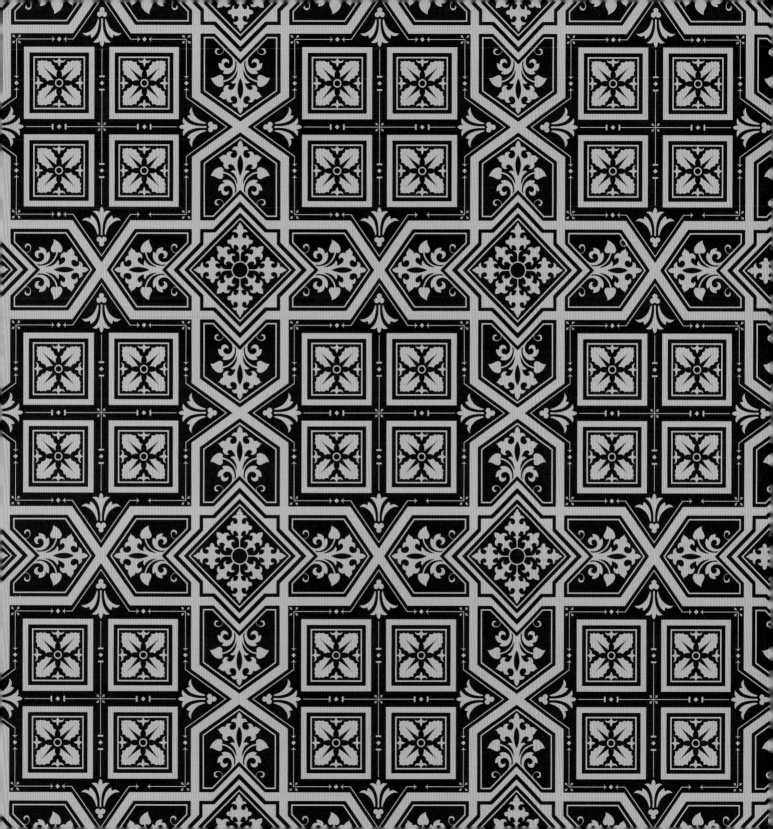

114

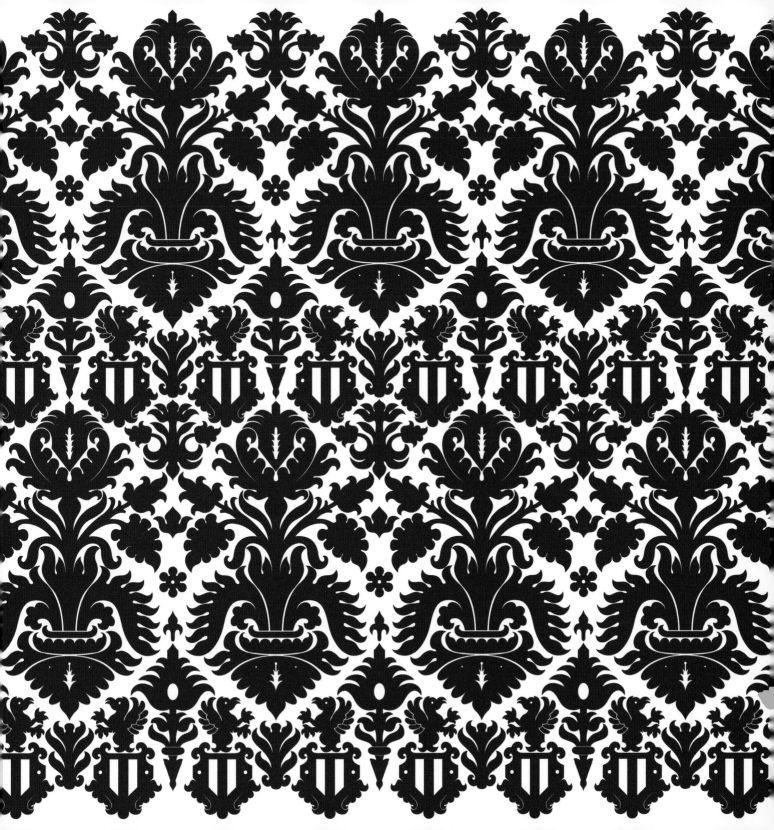

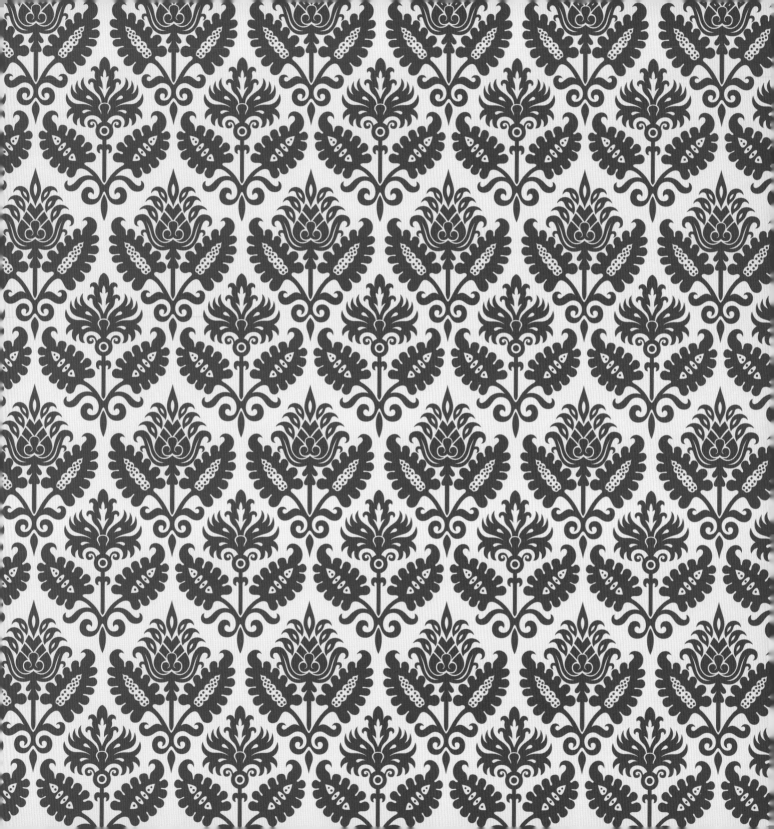

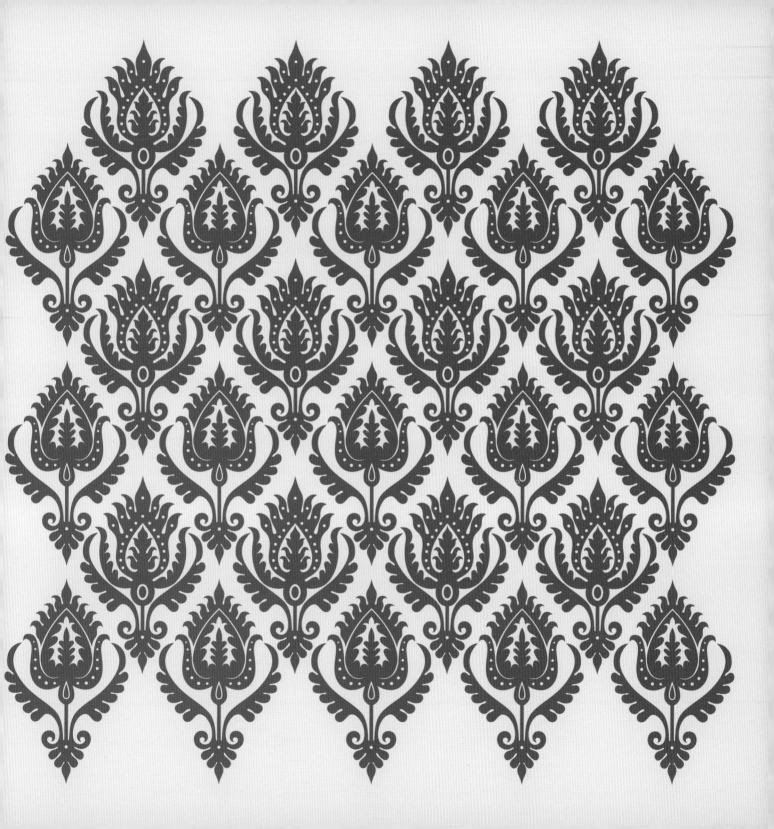

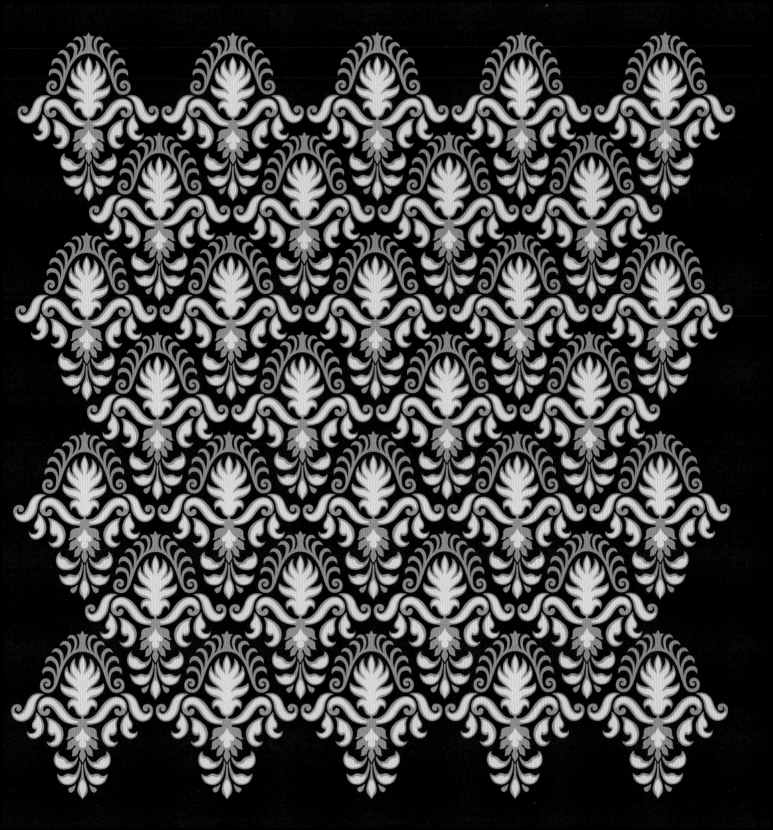

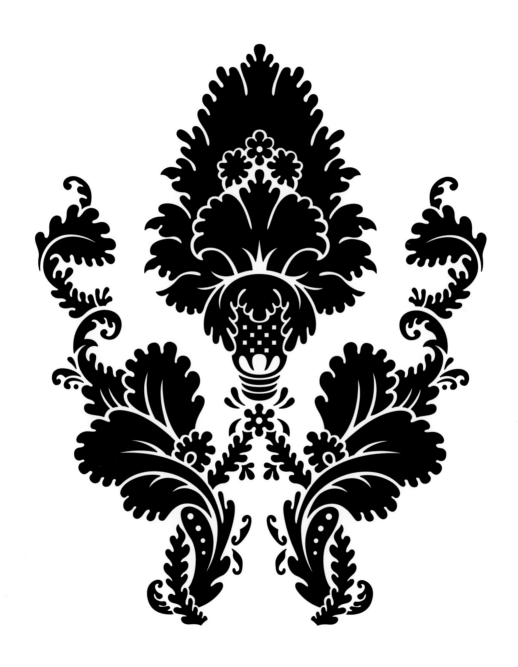

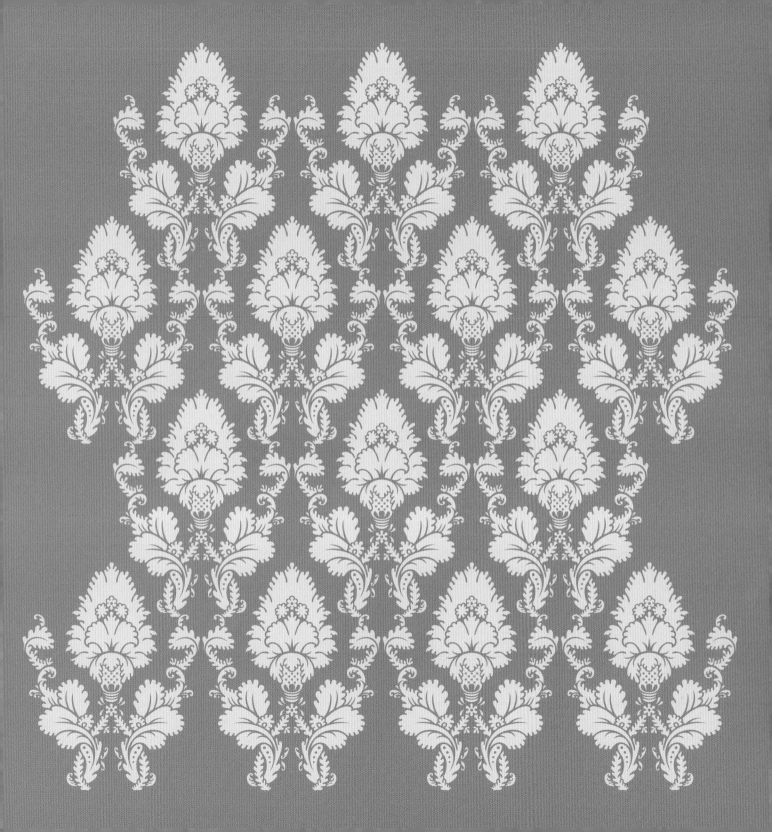

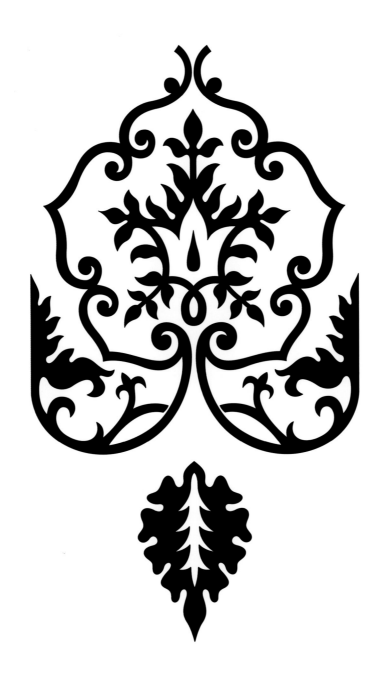

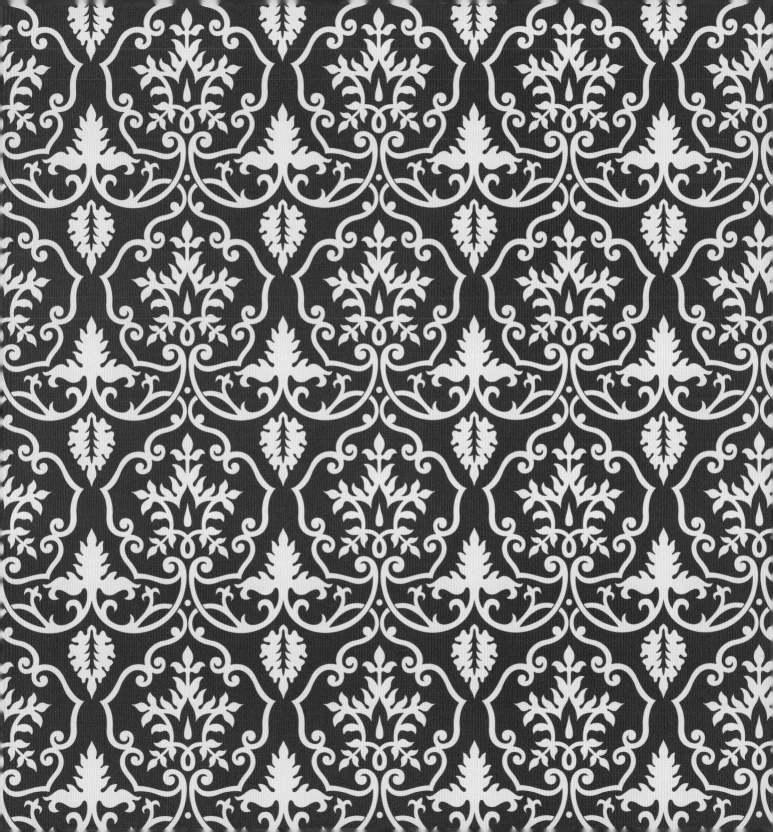

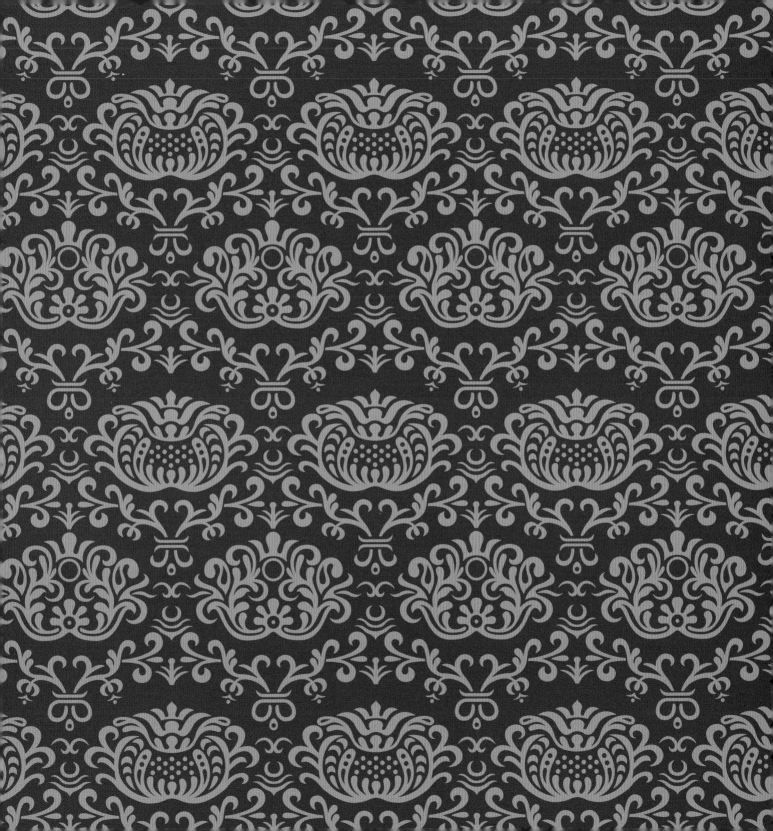

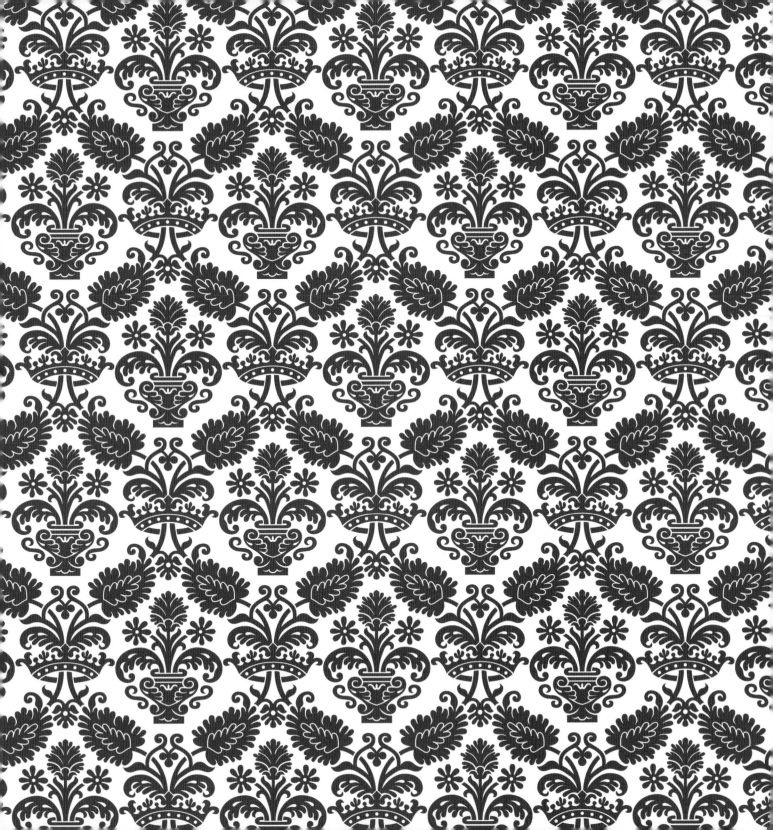

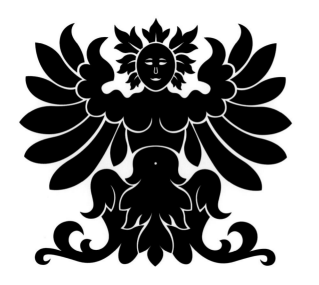

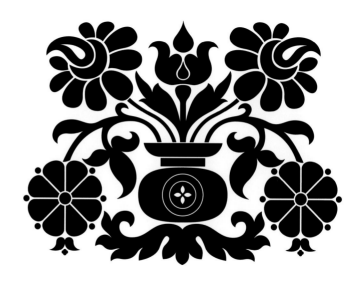

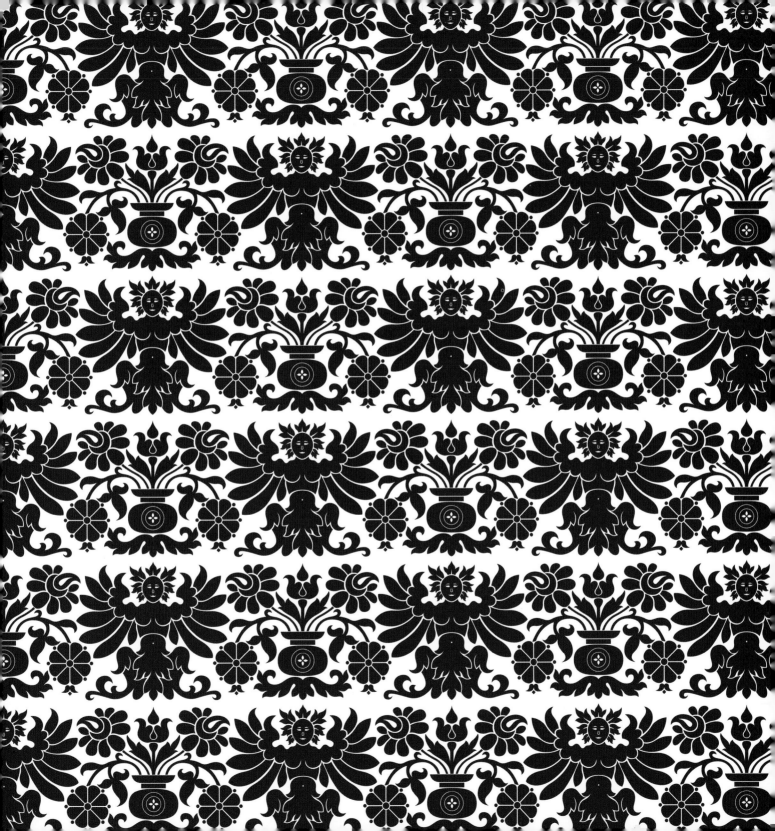

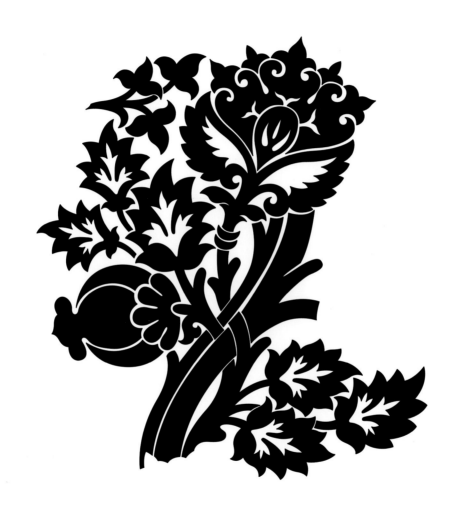

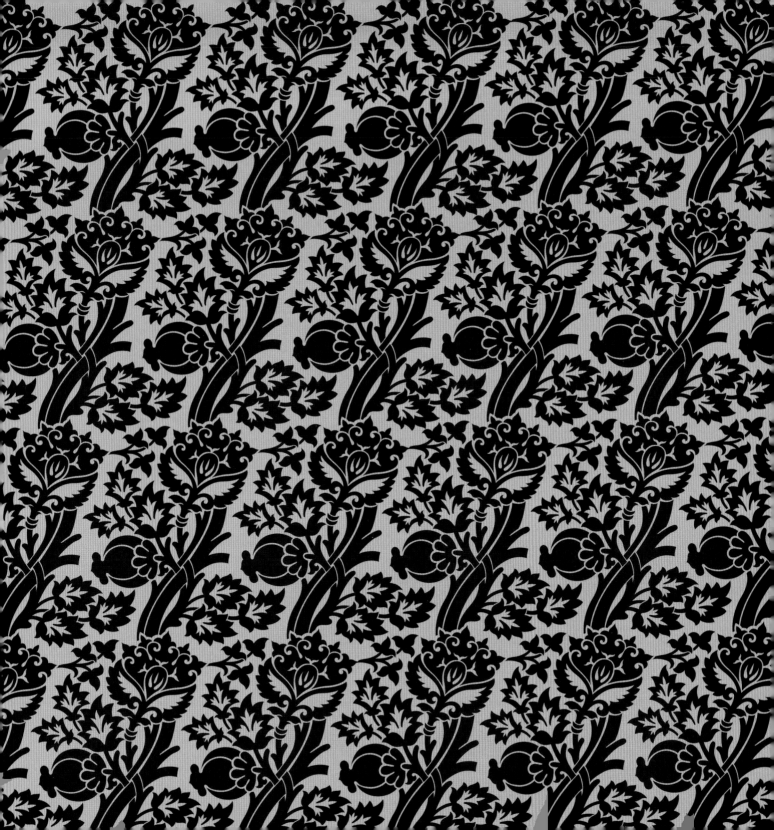

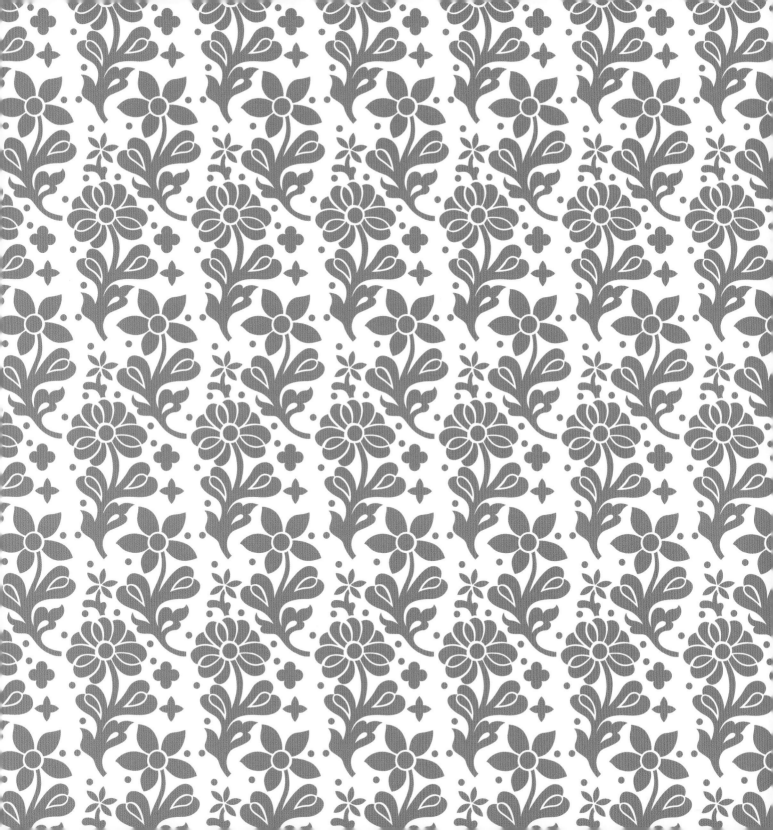

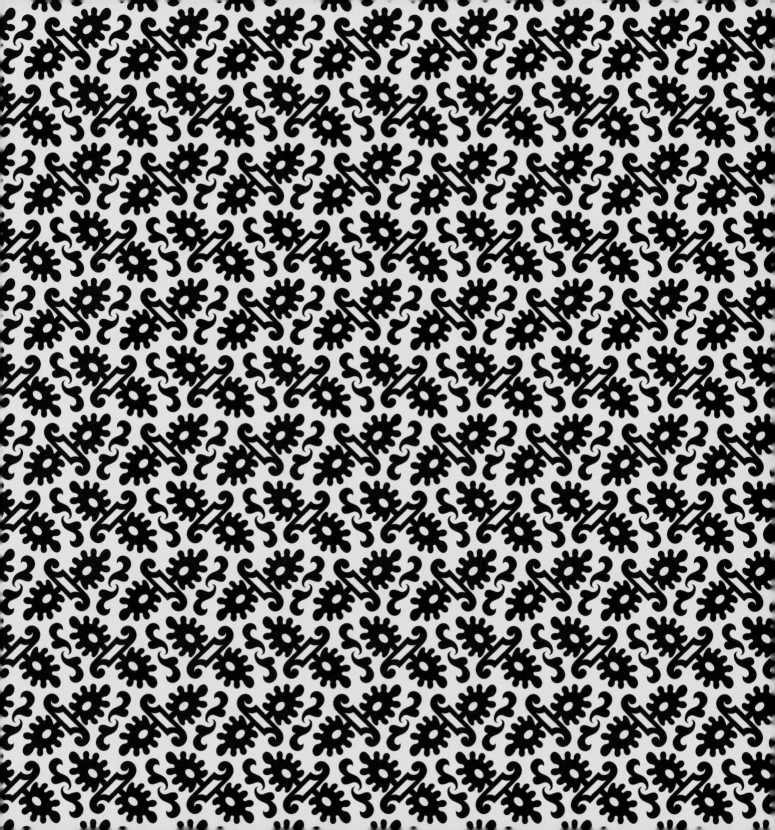

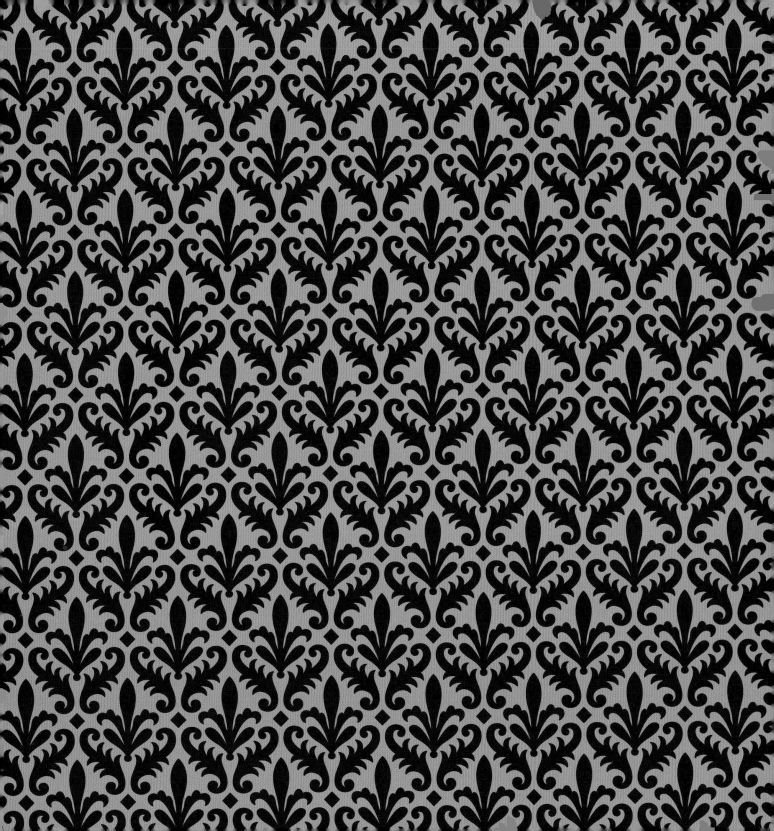

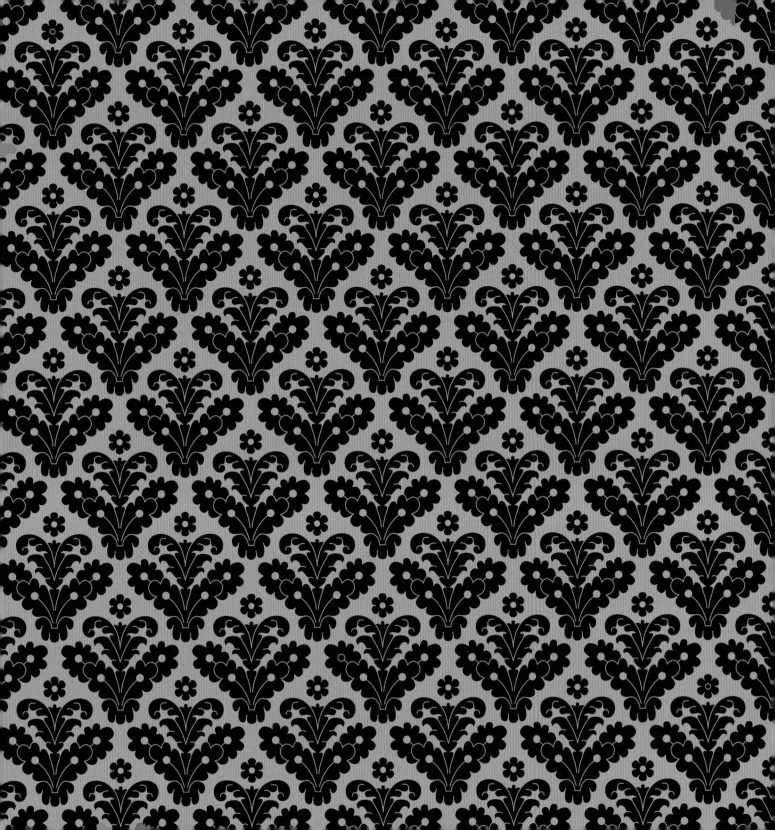

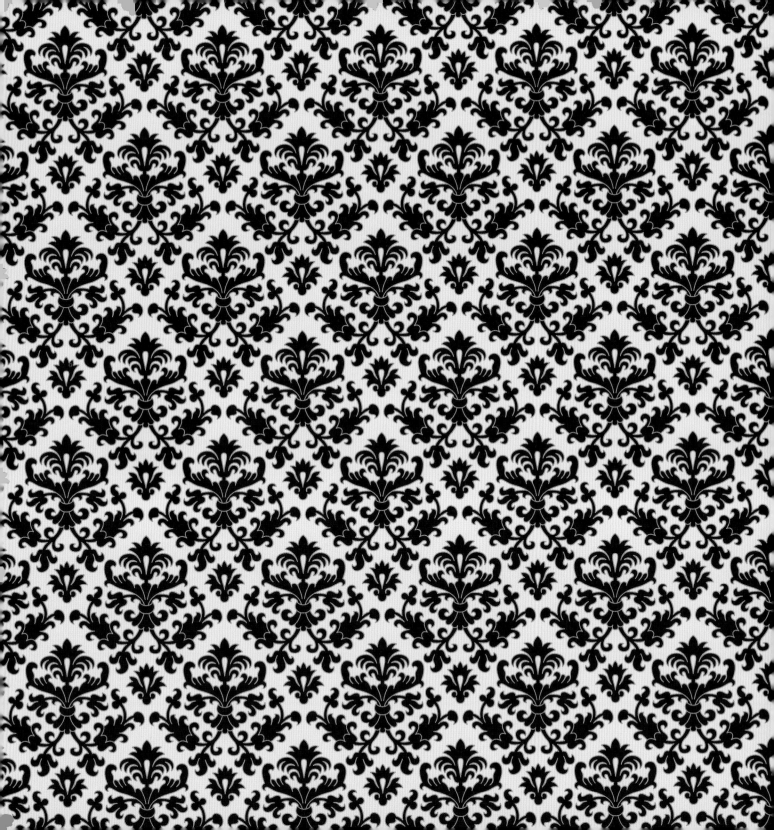

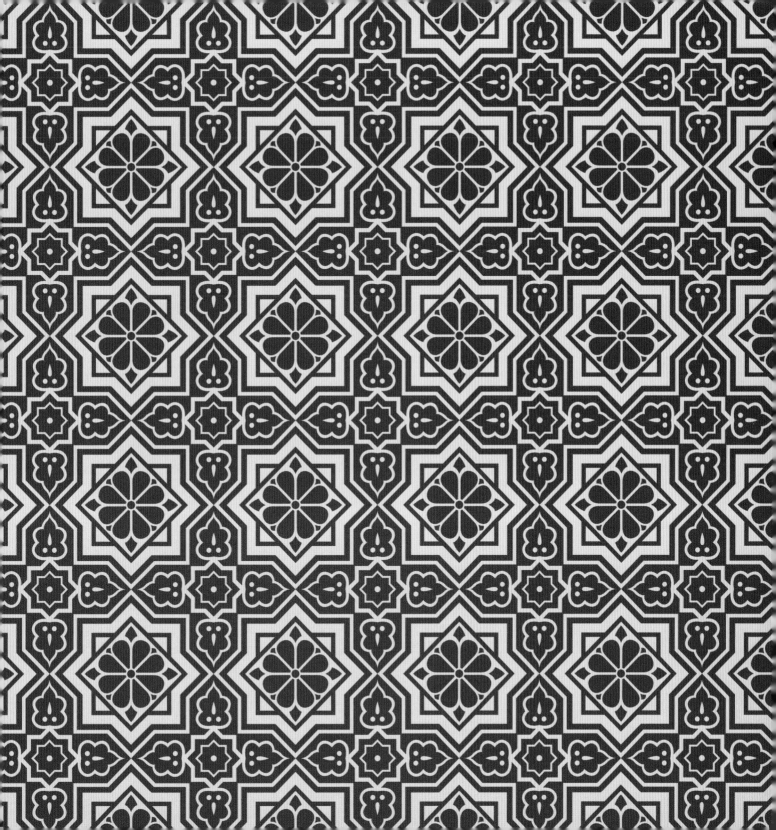

146

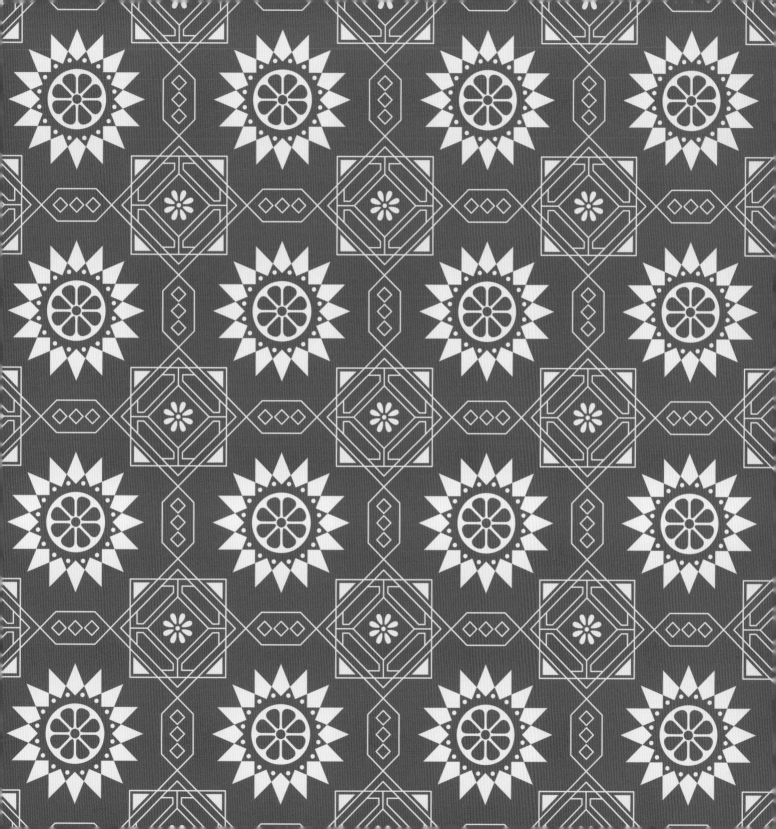

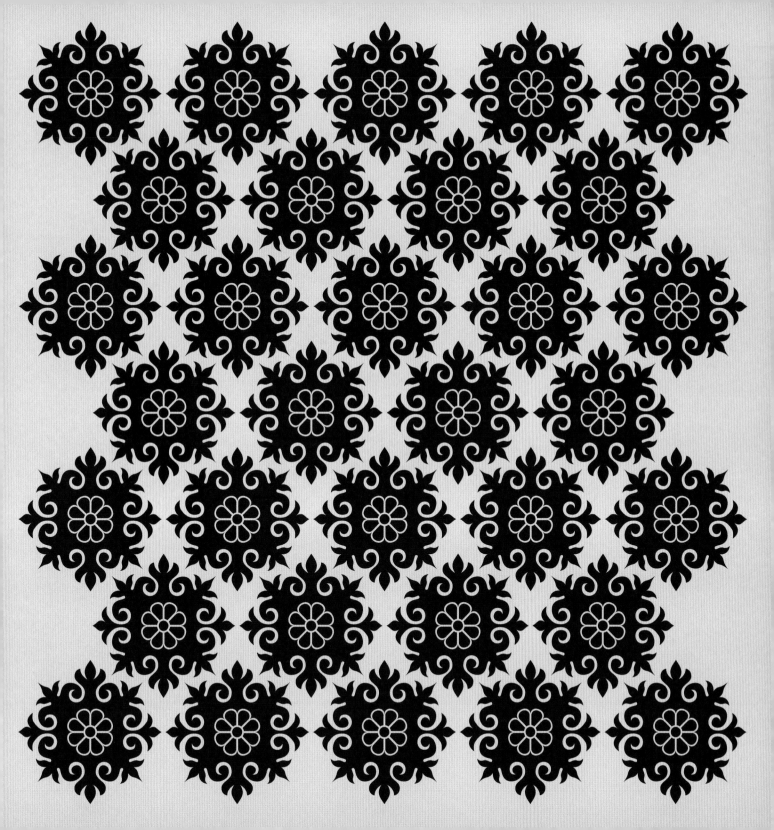

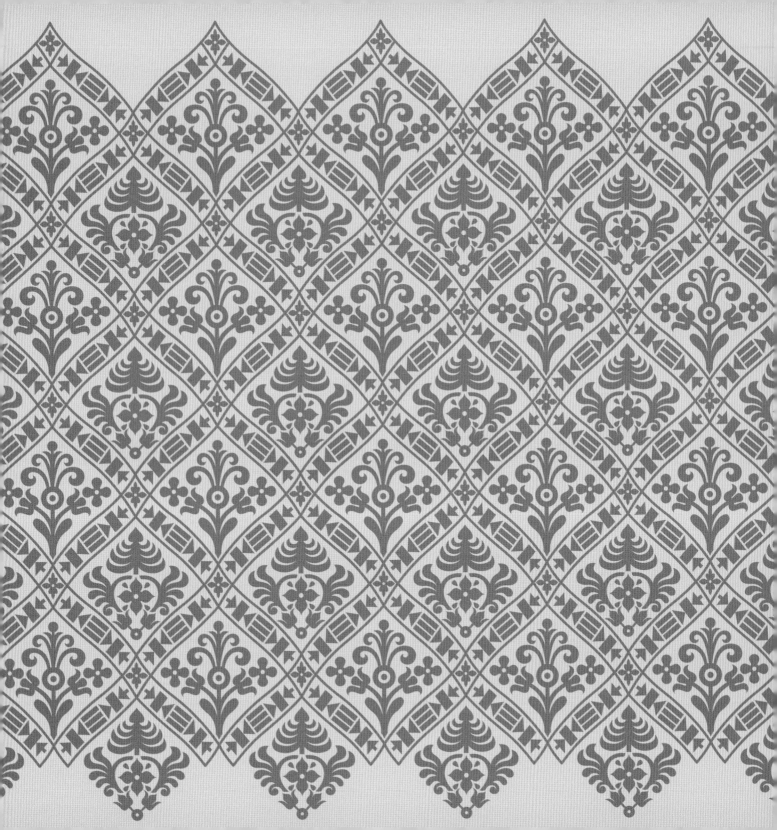

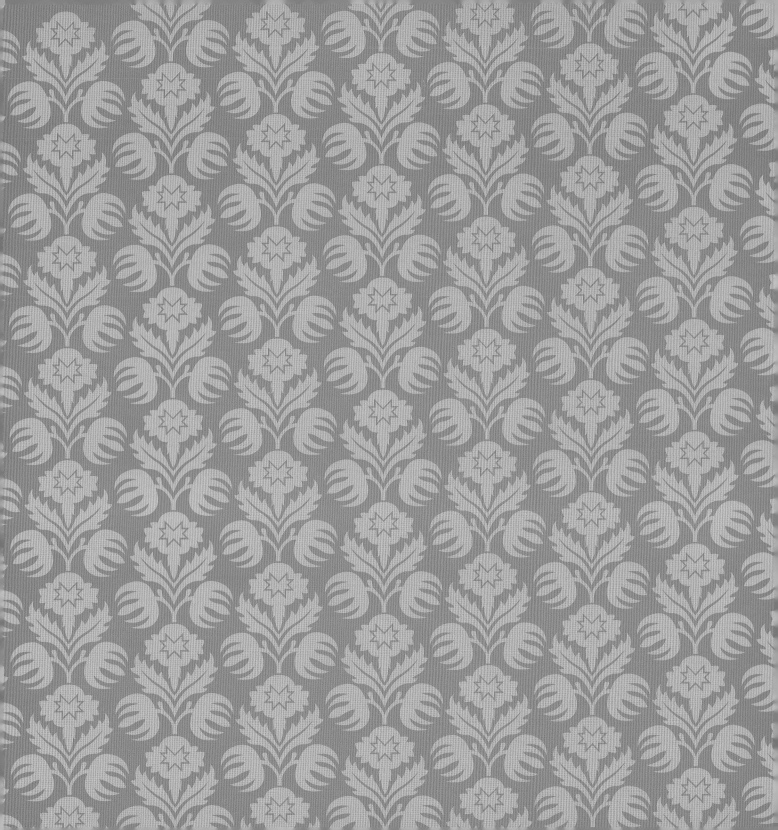

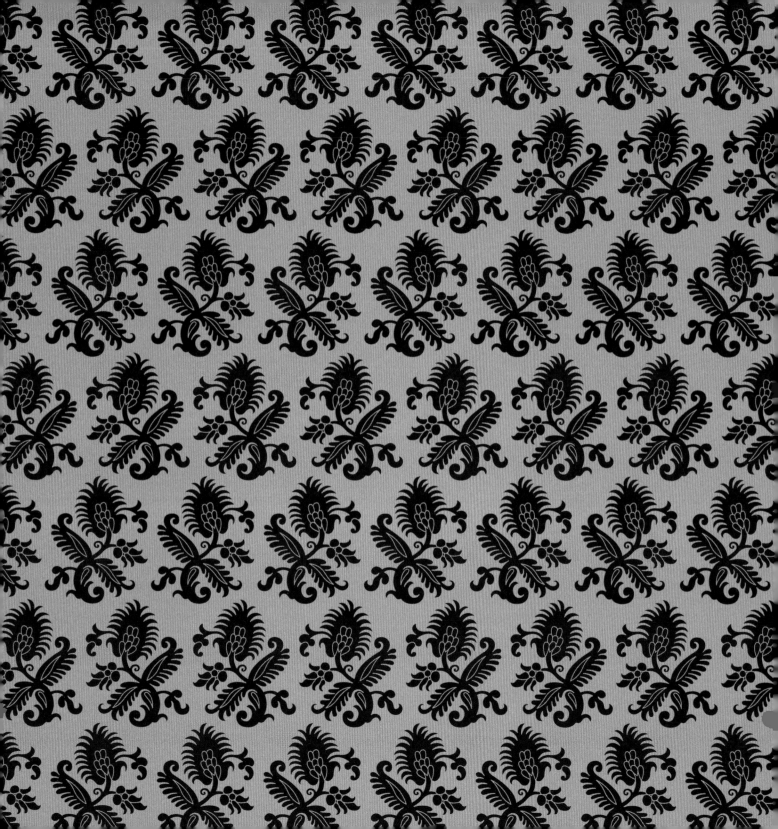

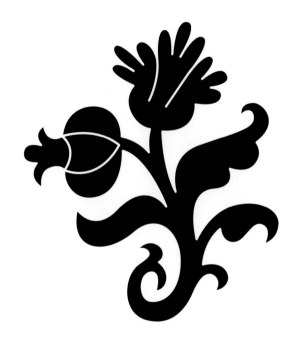
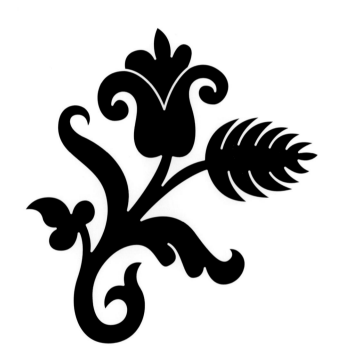

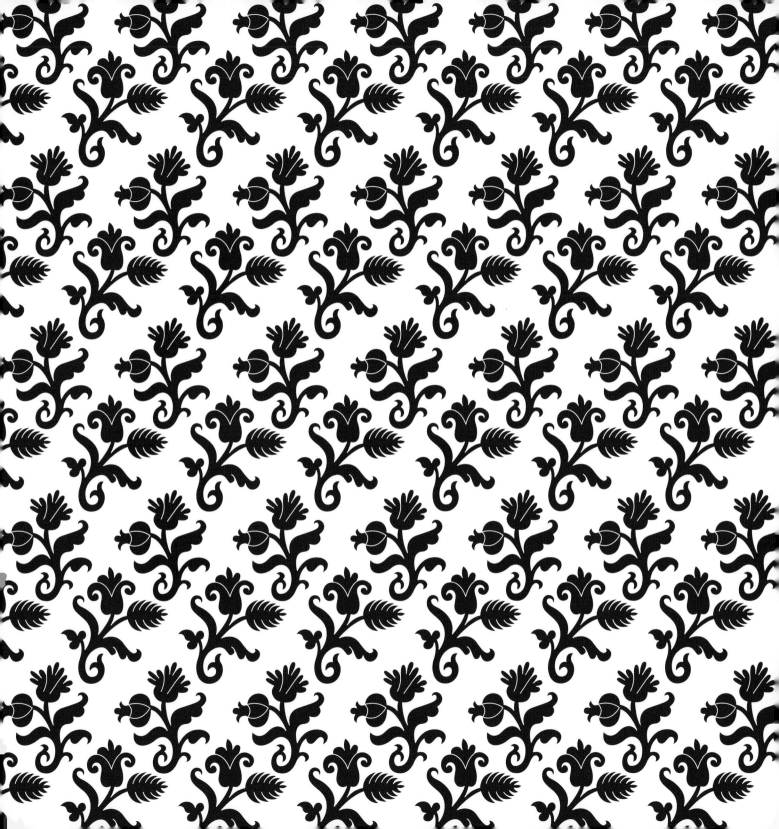

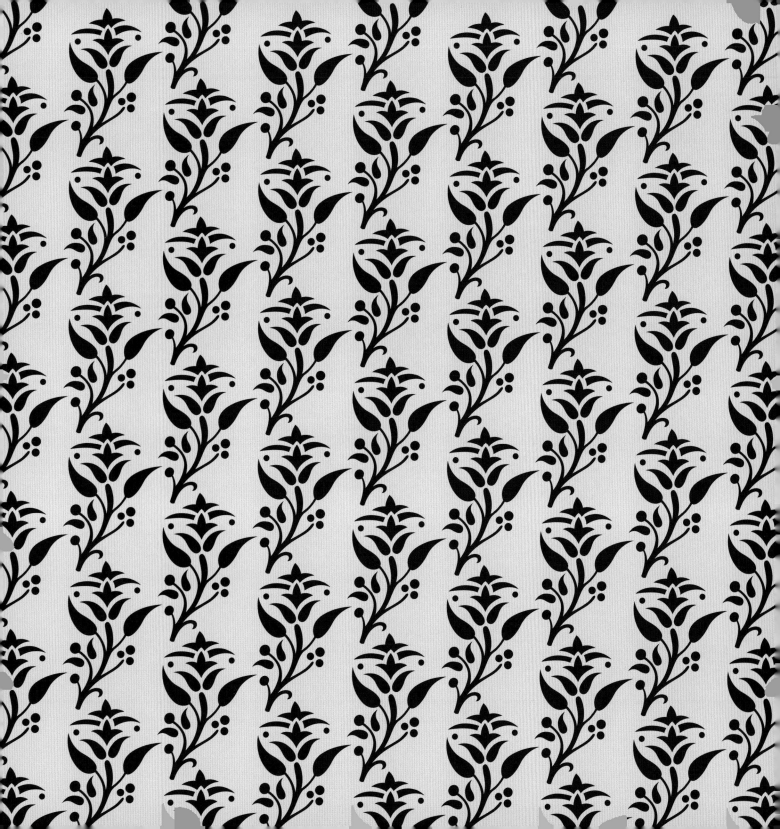

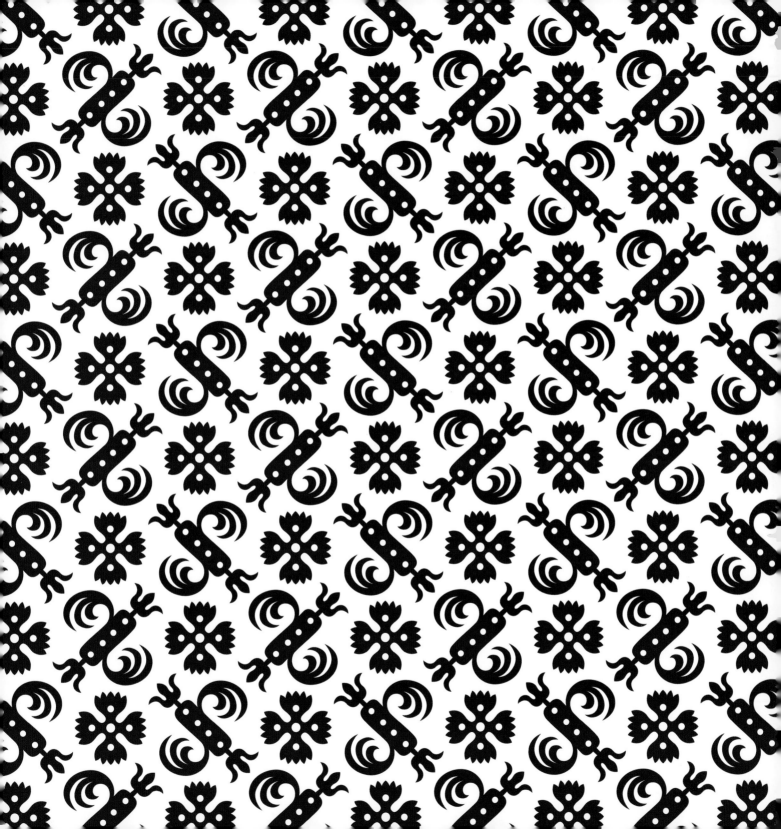

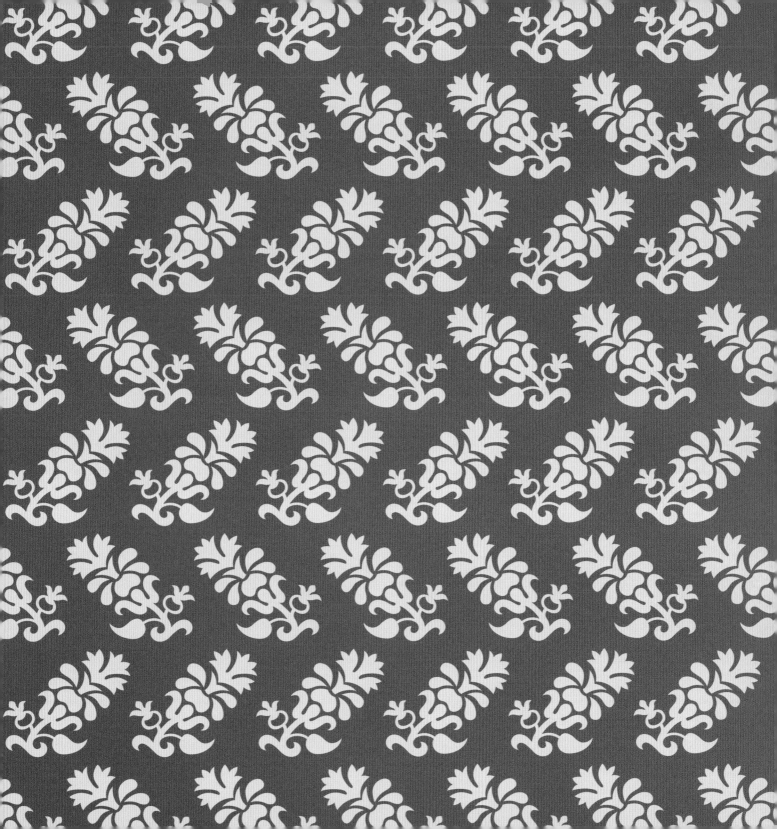

List of Images

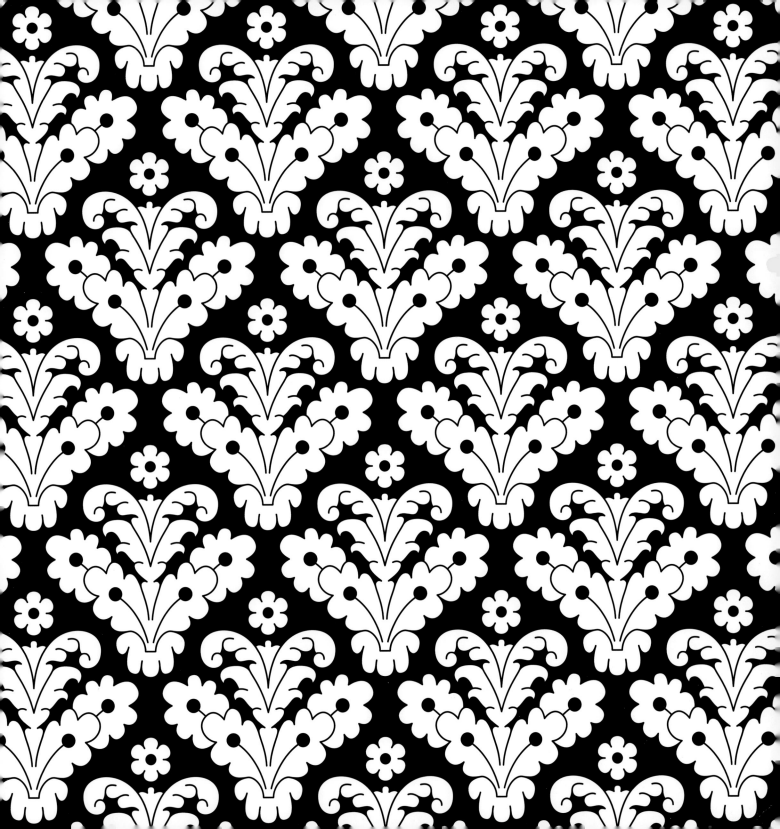

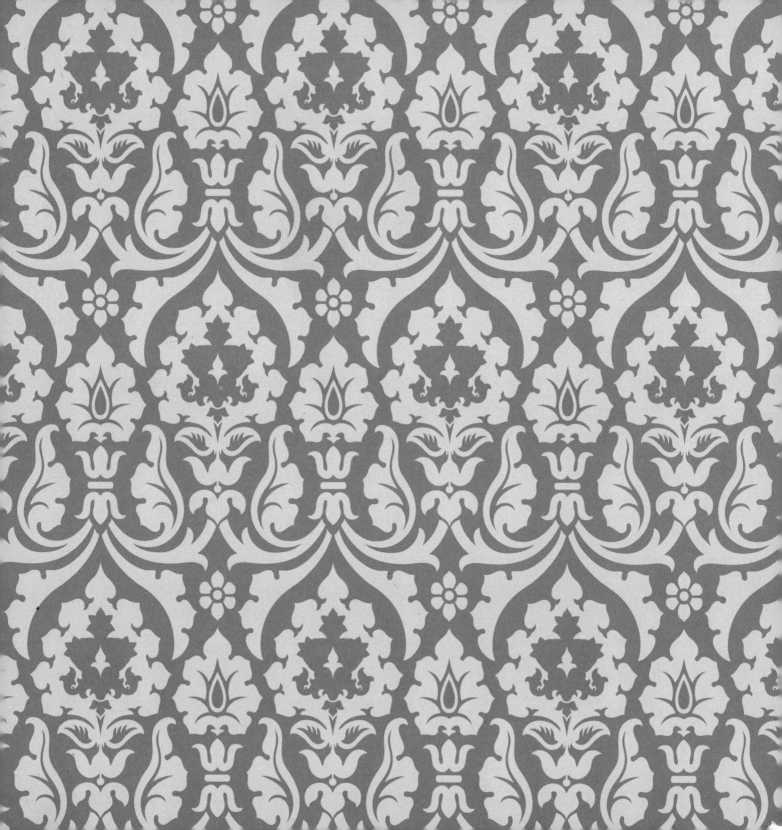